LIFE
DRAWING
IN 15 MINUTES

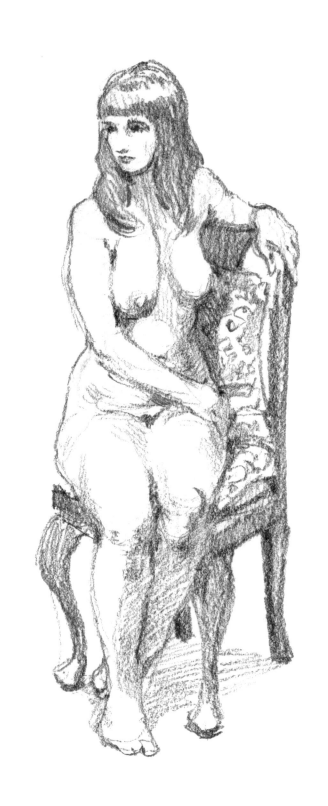

CAPTURE THE BEAUTY OF THE HUMAN FORM

JAKE
SPICER

LIFE DRAWING

IN 15 MINUTES

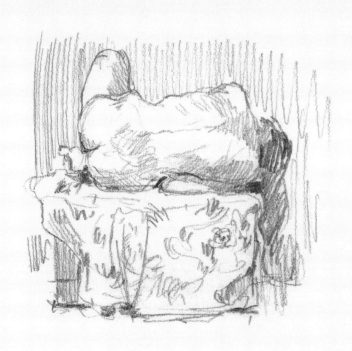

ilex

LIFE DRAWING IN 15 MINUTES

An Hachette UK Company

www.hachette.co.uk

First published in Great Britain in 2016 by

ILEX, a division of Octopus Publishing Group Ltd

Octopus Publishing Group

Carmelite House

50 Victoria Embankment

London, EC4Y 0DZ

www.octopusbooks.co.uk

Publisher: Roly Allen

Commissioning Editor: Zara Larcombe

Editor: Rachel Silverlight

Managing Specialist Editor: Frank Gallaugher

Senior Project Editor: Natalia Price-Cabrera

Art Director: Julie Weir

Designers: Grade Design

Production Controller: Meskerem Berhane

ISBN 978-1-78157-263-4

A CIP catalogue record for this book is available from the
British Library

Printed and bound in China

10 9 8 7 6 5 4 3 2 1

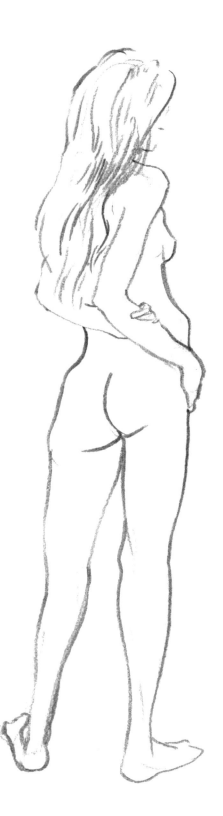

Contents

Introduction

Drawing is for everybody. Anyone can learn to draw, and anybody who can draw can always learn to draw better. Although some people have a natural aptitude for drawing, the ability to draw isn't a talent that you are born with; it's a skill that can be learned like playing a musical instrument or learning another language.

Why Draw?

You might draw as a hobby or as a way to impress friends with a neat skill; you might draw to communicate ideas at work in anything from carpentry to web design. Whatever your reason for drawing you'll find that the more you draw and the better you get, the more you realize it's not just about making a picture on a piece of paper; but learning to see the world in a different way. The draftsman's eye sees wonder in the mundane; to be able to see something and translate that observation into a drawing is a skill with more facets to it than simply art or illusion. Practicing drawing allows you to practice seeing.

The Language of Drawing

Drawing is a kind of visual language; a way of describing the observed world using a vocabulary of line and tone. Like a spoken language it has a certain grammar and structure that can be learned, developed, and adapted to suit the figures you want to sketch. This book serves as a guide, giving you some simple visual phrases for communicating fundamental elements of a figure; through practice and regular drawing you can develop a broader range and personal style. In time, your marks can become poetic, eloquent, and you'll become more fluid in your articulation and your visual description of what you see.

Beginning Life Drawing

This book is all about life drawing: learning to draw the figure from observation. You might have been to life drawing classes before, or be preparing to attend a class, or you might be reading this book to pick up general figure drawing advice.

When you first start learning to draw you feel clumsy, your pencil stumbling over lines as your tongue might stumble over a foreign phrase. If you're just starting out, improvements will come quickly, through big leaps in understanding, whereas if you've been drawing for a while, you'll find your drawings will become more consistent but you make fewer rapid improvements. The later, smaller leaps in understanding you make will help you to hone your drawings, consolidating the skills developed in your earlier practice.

It isn't the case with drawing that some people find it effortless and others find it difficult: everybody struggles at first. The frustration that can accompany drawing is a part of the discovery process; it encourages you to seek, to be curious, and to look harder at your subject. Without a certain amount of struggle, no learning would take place, so be gentle with yourself and stick with it.

Before launching into the drawing chapters, it's worth reading the next few pages—they serve as an introduction to drawing and a key to using the book. Enjoy.

Using This Book

15 Minutes

You can't learn to draw in 15 minutes any more than you can read this book in that time. With a little application, however, you can learn to make competent life drawings from a 15-minute pose. Every drawing you make will in turn make you a better draftsman; the really bad drawings you produce will be those you can learn the most from.

The aim of this book is to give practical advice that can be adapted to suit your needs. There are no right or wrong ways to draw, but there are better and worse ways of achieving certain kinds of drawings. To make a confident representational sketch of another person you need sound observational skills and a vocabulary of marks with which to describe the figure. What you can do with those skills once you've learned them is limitless.

Making Time to Learn

Learning to draw from a life model takes curiosity and application. It's a personal and open-ended journey limited only by the time you can put in and your enthusiasm for drawing. If you spend even five minutes drawing every day you'll make noticeable progress in a few weeks. Find time to draw for three hours each week and after a year you'll be able to do things you hadn't thought possible before; a year isn't a long time! If you have access to a life model or attend a life drawing class this book will provide you with structure for your practice; if you don't, there are plenty of ways to find figures to draw from, and the last chapter of this book contains advice for finding subjects to draw.

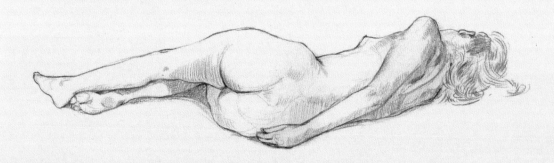

Chapter Key

This book is intended as a companion along the road of learning—it is not intended to teach you to draw so much as to help you teach yourself to draw. Take the book with you to life drawing classes, where you can use it to help structure your learning, or dip in and out of it to pick up useful tips and solve problems in your work. Here is a key to the following chapters.

CHAPTER 2: LIFE DRAWING
What to expect in a life drawing class and what you'll need in order to begin.

CHAPTER 3: ABOUT DRAWING
The drawing theory behind the practice; this isn't critical for the beginner, but will be interesting for the more experienced draftsman.

CHAPTER 4: BUILDING SKILLS
Exercises to get you started with drawing, to build your confidence, and to practice core skills once you are more experienced. These are particularly applicable to short poses in life drawing classes.

CHAPTER 5: THE 15-MINUTE FIGURE
An approach to use for drawing a full figure in 15 minutes, presented as a practical, step-by-step technique.

CHAPTER 6: GOING INTO DETAIL
A reference chapter full of spotlights on tricky areas of the figure. Dip in and out of it to help you solve problems in your drawings.

CHAPTER 7: RUNNING LIFE DRAWING SESSION
Advice on how to find a life drawing class, run a model sitting, arrange a space to draw in, and set up your own drawing session.

LIFE DRAWING

Life drawing is the practice of making an observational drawing directly from a model, typically unclothed. Although many artists employ life models for one-to-one sittings, most life drawing takes place in group sessions with several people drawing from one or more models. Here are a few frequently asked questions and answers about life drawing classes.

Why Go to a Life Drawing Class?

Learning to draw from life isn't just about making pictures of unclothed figures—it's a great way to exercise core drawing skills. Fundamentally, it is an exercise in observational drawing and it trains you to look properly at your subject, making selective sketches within the time constraints of a pose. At its best, a life drawing class can be the heart of an artistic community, encouraging skill-sharing and providing an environment in which to meet others who are keen on drawing.

Why an Unclothed Model?

Life drawing is all about drawing the essential human figure, devoid of the trappings of clothing and context. Although some classes will employ props, costumes, and sets, most life drawing concentrates on the unclothed form. The nude has been an enduring subject of art because it reminds us that we too have a body and that everybody is united by their common humanity. Drawing the body without clothing also provides insight into the shapes and anatomy that make up the human form.

Who Goes to Life Drawing Classes?

Life drawing is for anybody who wishes to learn to draw, and people from all walks of life attend classes. Whether you are drawing for pleasure, learning, or professional development, everybody can find value in the process. Art students draw to develop portfolios; art professionals like illustrators, animators, and games designers draw to

practice necessary skills. People of all ages go life drawing for a creative outlet, to meet like-minded draftsmen, or to learn a new skill. Life drawing is even used by the business community, such as doctors, engineers, and architects, to promote creative problem-solving skills and practice visual communication.

Do You Have to Be Good at Drawing to Go to a Life Drawing Class?

Different drawing classes are often pitched at different levels of experience. If you've never drawn before then structured beginners' classes are the best place to start. Drop-in classes are often open to all abilities and you shouldn't be put off attending by your inexperience. You only learn by doing, and everybody can learn to draw. Just make sure you've done some research first; read through this book and go in prepared! Very few classes are pitched solely at experienced artists, and this will normally be clearly advertised.

Philosophy and Practice

Life drawing is a process as much as a way of creating drawings. It teaches a certain way of seeing as well as promoting rigorous problem-solving and decision-making. Drawing is often tightly bound up with image-making, but as a visual language drawing can simply be used as a tool for communication. A life class provides a novel and valuable opportunity for the unclothed human body to be seen outside the sexualized context of modern media portrayals of nudity.

Historical Context

Within the visual arts, the human figure is the most commonly depicted subject. The concentrated study of the unclothed model has been an enduring practice of painters, sculptors, draftsmen, and artists of many disciplines. Once a fundamental element of an artist's formal education, in time life drawing has become a less central discipline in art schools and has broadly been democratized, with contemporary life drawing flourishing in artist-led classes and adult education institutions as much as in universities and schools.

A Life Drawing Class

A life drawing class takes many forms. Structured courses might prescribe the materials you use and how you approach the drawings, and involve tutorial interspersed with exercises. Untutored classes will allow you free rein, with the tutor simply keeping time on poses, so you'll need to go in feeling prepared. Check whether materials are provided before attending, and always bring a basic kit just in case they are not.

Remember that the model sitting for the class is a person, not just a subject for the drawing. Be considerate in your language towards them and judge the etiquette in the class. It is amazing how many people are too embarrassed to thank the model for posing but feel comfortable complaining about movements in their pose to the tutor. Respect the model—they are the source of inspiration for your work!

What to Expect

Here's a life class in the round, with students exclusively using easels and the model positioned in the center—a common setup in tutored classes in well-equipped art schools and adult education centers.

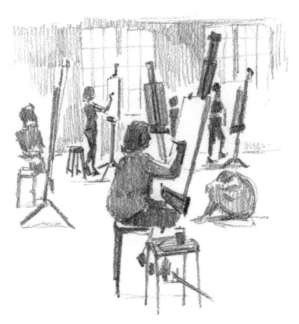

The simplest life classes might just provide you with a chair and a model. These classes are often untutored and could be run anywhere, from bar function rooms, to town halls, to an artist's studio.

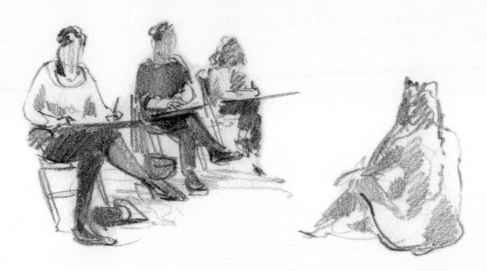

Many classes will allow the option of sitting or standing, with a few easels provided and students arranging themselves according to their own preference.

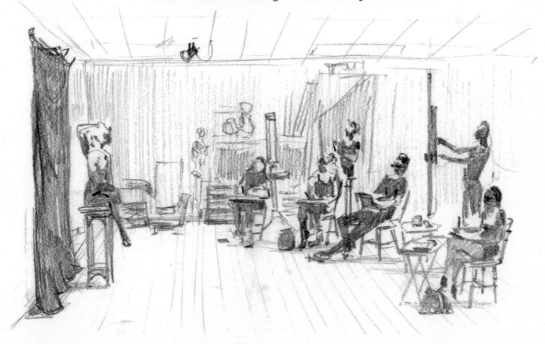

Setting Up

Setting yourself up effectively can be as important to make a good drawing as the technique you use to make that drawing. When you set up, think about the following:

- Position: Where you place yourself in relation to the model will affect the types of poses you get. Some positions may give you lots of back views, profiles, foreshortened poses, etc.
- View: Make sure you have a clear view of model and that your paper is well lit.
- Materials: Make sure you have enough paper, that it is secured on your board, and your materials are close to hand.

SITTING DOWN TO DRAW:
Avoid working flat on a table—it can distort your drawing.
a) Support your drawing board at an angle using a second chair, edge of a table or a stack of books.
b) Make sure you can easily look from your drawing board to the model.

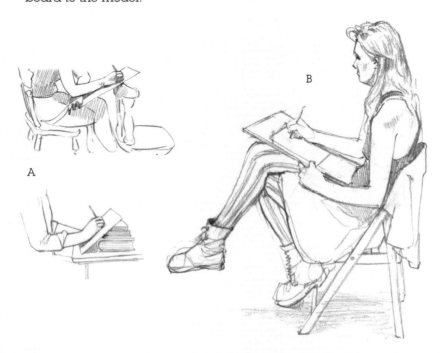

A

B

STANDING AT AN EASEL TO DRAW:

a) Secure your paper.

b) Try not to cross your body with your arm as you draw. If you are right-handed, keep your easel to your right and vice versa.

c) Adjust your drawing board to the ideal height, so that it's comfortable to draw on the paper without obstruction.

d) All easels have their eccentricities—make sure all of the nuts and bolts are tightened up.

e) Ensure that you can see the model and your drawing at the same time; don't let your drawing board obstruct your view.

f) If possible, give yourself space to stand back from the easel to appraise your drawing.

g) Set a good angle for the easel.

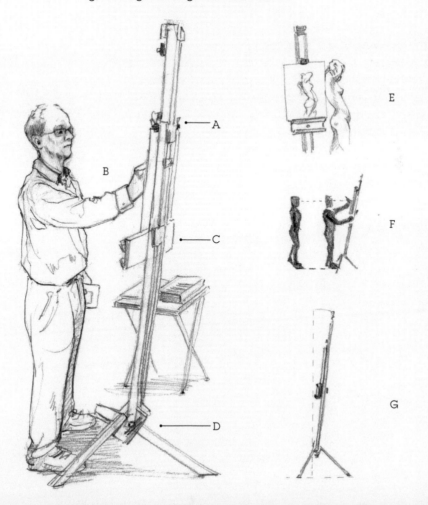

A

B

C

D

E

F

G

Drawing Materials

Your Materials

Life drawing is a tactile process and the materials used to
make a drawing are key to its success. A well-executed
drawing made with poor implements on the wrong paper
just isn't a good drawing. The techniques described in this
book can broadly be applied to all drawing materials—
you'll find that you'll need to adapt the approaches for
different media.

Always start simple. Pencil and charcoal are staples
of drawing because they are so versatile. Over time you'll
find the best materials for you—experiment with different
drawing materials and papers before you settle on a
combination you like. Once you find something you get
on well with, be fussy, and don't settle for less than the
ideal but equally don't be afraid to continue innovating
and experimenting. The following pages contain more
details on basic monochrome materials, deliberately
leaving out coloured media like pastels, paints, etc.,
which nonetheless are all excellent and valid mediums
to use in a life class.

Transporting Your Kit

You'll need to transport your drawings to and from the
class. For instance, if your drawings are in charcoal or
pastel, spray them with fixative before packing them
away—you can put layers of paper in between to
protect them. Paper can be rolled and carried in art
tubes: heavier paper and drawing boards may need
to be carried in a folder or portfolio.

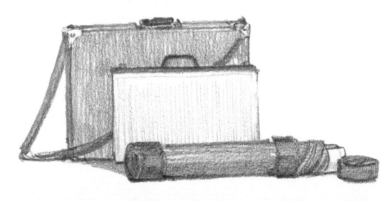

A Basic Life Drawing Kit

If you haven't been asked to take specific materials to a class, the following kit is a good starting point. Don't overwhelm yourself with too much if it's your first time, but make sure you go to the class prepared. The board and paper could be any size you prefer, and the smallest, simplest basic kit would include a sketchpad and pencils.

a) Drawing board
b) Board clips
c) Paper
d) Sketchpad
e) Pencil case
f) Willow charcoal
g) Pencil
h) Sharpener
i) Plastic eraser
j) Putty eraser
k) Folder

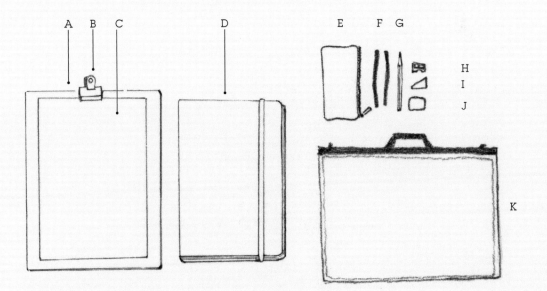

Paper

You need paper that suits your drawing material: the tone, color, and surface texture will make a real difference to how your marks appear.

TYPE OF PAPER

Heavy, good quality drawing paper (for example cartridge paper) is ideal to draw on. Watercolor paper is absorbent, is often textured and is good for wet media or a drawing style that requires heavy texturing. Specialist papers should be acid free, have longevity, and be resistant to discoloration. Construction paper (or sugar paper) is cheaper and grainier than drawing paper, is often colored, and will age badly. Plain newsprint or lining paper (wall paper) can be used if you need to economize but will discolour, becoming yellow and brittle over time.

COLOR AND TONE

Bleached white paper is most common, but off-white, ivory, or buff is often preferable for drawing on—it will show off drawn marks more sympathetically and can be heightened with white. You can use colored papers but if you do, test how your chosen medium looks on the paper first.

WEIGHT

Weight of paper is measured in pounds per ream (poundage or lb) or in grams per square meter (gsm). Papers between 65–120 lb (100–200 gsm) are good for drawing on. The paper's weight affects the feel of the mark on the page although weight doesn't always relate to quality—you can get very lightweight Chinese and Japanese papers for specialist tasks, for example.

SIZE

When you are choosing what size of paper to draw on think about the practicalities: small sketchbooks are good for taking out and about whereas a static setup with an easel will allow you to use large paper. Also think about what kind of marks you want to make. Small paper encourages short marks from the fingers and wrist and can be covered quickly, while larger paper encourages sweeping marks from the shoulder and elbow.

Drawing Boards

You'll need a flat surface to rest your paper on, ideally something you can hold at an angle and take around with you while sketching. A rigid, lightweight piece of board, slightly larger than your paper is ideal—pegs, clips, or masking tape will secure your paper in place. Some life classes provide these boards, some do not.

Sketchbooks

Sketchbooks are practical and personal—they protect your paper, keep your work in order, and small sketchbooks are easy to carry around. Ringbound books can be folded back giving a flat plane of paper but the bindings can break if treated roughly. Hardback sketchbooks are naturally supported; softback books can be cheap but bend easily. Always think about the type of paper in your sketchbook and find a size and dimension that suits your purposes. Loose paper can always be bound into a sketchbook later.

Pencils

For drawing, graphite (lead) pencils give smooth, gray marks with a slightly shiny surface. Graphite pencil is very adaptable, can be rubbed out cleanly, and gives a controlled line. Pencils have different grades, measured on a scale of 9H–9B with HB in the middle; H stands for hard and B for black.

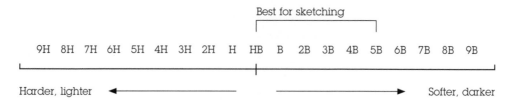

Best for sketching

9H 8H 7H 6H 5H 4H 3H 2H H HB B 2B 3B 4B 5B 6B 7B 8B 9B

Harder, lighter ← → Softer, darker

GRAPHITE POWDER

Avoid smudging pencil with your finger as it can be difficult to control; if you want to achieve soft tones you can buy powdered graphite that can be applied to your paper with a finger, paintbrush, stump, or tortillon (a blunt shaping tool made of rolled paper).

SHARPENING

Pencils should be kept sharp for consistent drawing. Sometimes you'll want a blunt pencil so that you can achieve a wider, softer line, in which case you can use sandpaper to wear one edge down.

ERASERS

Putty erasers come in grades of softness. They are malleable, get dark with use, and are best as an application for rubbing out charcoal or graphite powder. Plastic erasers come in various qualities with cheap not always meaning bad—test a few to see how cleanly they rub out. Cut your eraser to a point so that you can use it as a drawing tool and keep it clean to avoid unwanted smudging.

Charcoal

Charcoal is black and gives a varied, expressive line. The medium wants to smudge, and can be rubbed back with the hand and drawn into with an eraser to create light. Because of the difference in the quality of their surfaces, charcoal and graphite don't always mix well. A spray-on fixative or hairspray can be used to reduce smudging once a drawing is complete.

WILLOW

Willow charcoal comes in irregularly sized sticks. It snaps easily and can be used on its side, point down or crushed up and applied as powder. Vine charcoal is a more expensive alternative to willow, which gives greater control and subtlety.

COMPRESSED

Compressed charcoal is a dense black medium. It comes in uniform sticks, is harder to smudge than willow and doesn't rub out easily. Conté crayon, made from compressed charcoal and a clay or wax, is a good alternative with similar qualities.

PENCIL

Charcoal pencils are made from compressed charcoal in a pencil casing. They are often graded on a scale of darkness and tend to give greater control over line than other charcoals.

Ink

Most ink pens cannot be erased, but do give clean lines, encouraging bold decisions in drawings, and are a good choice for linear mark-making. Water-soluble ink can be wetted with a bush and used for painting in tone; wet mediums will require heavier paper to prevent the paper from buckling.

Pens

Ballpoint pens are cheap, versatile and give a varied width of line. Fineliner pens provide a constant weight of line with better quality ink than ballpoints. Brush pens give a varying weight of line and are tricky to handle but with experience can be very expressive. Good quality felt-tipped pens make bold, graphic marks, and are often popular in life classes. With pens as with all mediums, it isall about finding out what suits you, and you may find you want to carry a variety of pens for different types of marks that will give radically different results. It's also great to experiment with pens when they're running out of ink. Be careful, though, not to smudge wet ink with your hand as you work.

DIP PENS AND OTHER IMPLEMENTS

All sorts of drawing tools can be dipped into pots of ink and drawn with. Dip pens give a wonderful variety of line and a surprising amount of control—use a drawing nib rather than calligraphic nibs and generally avoid mapping nibs as they can be too fine and delicate. Experiment with using brushes, bamboo, straws, feathers, etc., to dip into ink and draw with.

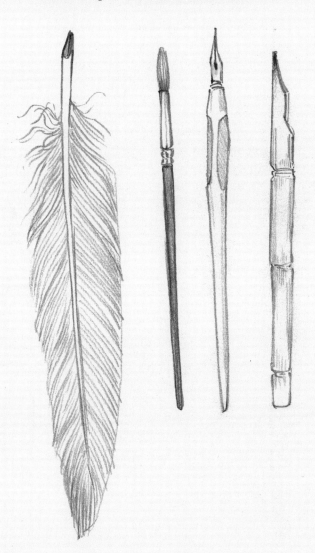

Drawing Without a Life Class

You won't always be able to get to a life drawing class,
but you want to create as many opportunities to practice
your drawing as possible. Have a look at chapter 7 for
advice on how to set up your own session, or run a sitting
with a friend. If you can't find a class, or want to practice
on your own first, here are some tips on drawing without
a model.

Be Your Own Model

In the absence of somebody else to draw, try modeling
for yourself! Draw your own hands and feet from life or
set up a mirror for a self-portrait—all the principles of
figure drawing will still apply, except you'll only have
yourself to blame if your model fidgets.

Draw from Reference

Drawing from a live model will exercise all the skills of observational drawing—copying from a two-dimensional image wont be the same and will exercise fewer skills, but can still be a valuable exercise. While not a substitute for life drawing, drawing from photographs, paused television, or a computer screen will allow you time to improve your draftsmanship and will allow you to capture poses that a model couldn't hold for a sustained period.

Get Out and About

Whether you're at home, in the park, on the bus, or in a café, there will often be people standing still for a few moments at a time. Use every opportunity to practice the core skills of drawing—carry a small sketchbook everywhere you go and try adapting the exercises in Chapter 4 for sketching out and about.

ABOUT DRAWING

This chapter focuses on ways to think about drawing, complementing practice with a little theory. The more time you spend drawing, the more you'll appreciate that it isn't just about making pictures; it's about learning to see the world differently. If you're just starting, you might want to skip ahead to a more practical chapter—you'll learn more from drawing than reading. When you are a little more experienced and wish to delve deeper into the process you can return to this chapter to help broaden your understanding.

Attitudes and Techniques

Attitudes are ways of thinking about and approaching life drawing. The attitude you take to the practice of life drawing is as important as the techniques you use to make individual drawings. Techniques, such as the ones in this book, give you a starting point and a process to work through when translating your observation of the three-dimensional world into a two-dimensional drawing. Take all techniques with a pinch of salt: there is no right or wrong way to draw, just better and worse ways of achieving a certain outcome.

Some techniques help you structure your time, the way you think about your subject, and the way you make your drawing, while others provide clever tricks to make your drawing more striking. Use and adapt the techniques suggested here: combine them with other things you've read or been shown by fellow artists, discarding any approaches that don't suit you and bringing in your own understanding of the visual world. Given time, you can be sure of developing an approach to drawing that is robust, authentic, and unique.

Expectation and Intention
Rather than having expectations about the outcome of your drawing, aim to maintain integrity in your process. If you're making an observational study of a person, make sure you really look at that person, and that each mark you produce is the result of a clear observation. Every drawing you make

should be made for a reason. It helps to know why you are making a drawing before you make it, even if that decision happens moments before your pencil touches the paper.

When you draw from life you are selecting the elements of a model that you've found interesting, which you reveal to viewers of the drawing through your marks. When your model strikes a pose, you might find yourself captivated by the shape their whole figure makes in space, or by the gesture of their hand, or their expression. You might also be making the drawing with a particular purpose in mind; to study their musculature, capture a sense of light on the surface of skin, or to practice your portrait drawing. Focus your effort on the element of the pose that your find engaging and consider the purpose of the drawing as you make it. First look, formulate an intention, then draw with that intention in mind.

Risk and Failure
Failure is an integral part of learning. The successful drawings a draftsman makes are the tip of an iceberg of weaker drawings. It is important to maintain confidence when drawings fail and to learn from a drawing that doesn't work in the way you would have liked. See all the drawings you make as part of a wider practice: every now and again you'll make life drawings that are successful, but realize that most of your drawings will simply be learning opportunities. Always be prepared to take risks in your work.

Style
Style is an elusive thing. Given the same medium and model we will all create different drawings with unique marks and emphasis. It's often only possible to understand your own style by going back over a body of old drawings to discover the patterns. Study the drawings of artists you respect, and of friends who draw. Learn lessons from their work by looking at how they have solved particular visual problems, what kind of marks they have made, and what they are trying to say about their subject. Avoid simply copying, but use their drawings as a key to understanding how to improve your own. Don't worry about your personal style, as it will develop over time and you'll often only recognize it retrospectively.

Sources of Imagery

When we draw we create our drawings from three sources of imagery, observation, memory, and imagination. It is important to recognize that these overlap—when you are drawing from observation, you are having to hold visual information in your head as a brief memory before the mark is committed to paper and you'll always be using you imagination to inform how you arrange and simplify your subject on paper.

Observational drawing is valuable because looking is the starting point. The visual memories that inform our imagination are amalgamations of things we have observed around us. Your visual memory improves as you draw more, and you can exercise it further by trying to draw models from memory after a life class. Drawing figures from your imagination often relies on having a well-developed "internal mannequin"; an imaginary model of how the figure works developed from observation and repeated drawing of the body which you can use as a basis for imaginary figures.

DRAWING FROM OBSERVATION

Directly looking at your subject, either from life or from secondary material:

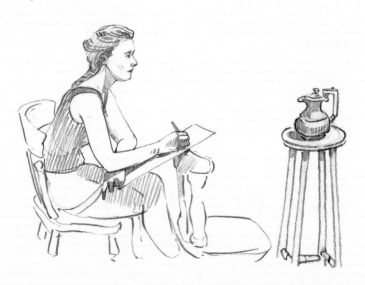

DRAWING FROM MEMORY
Basing a drawing on what
you've previously seen and
committed to memory:

DRAWING FROM IMAGINATION
Basing your drawing on "schema,"
established ideas of what something
might have developed from
amalgamated sensory memories:

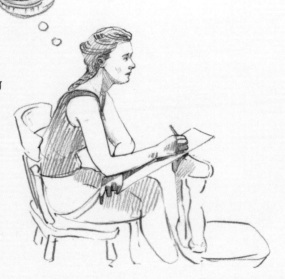

Perceptual Skills

We use perceptual skills to break the complex visual
world down into manageable, drawable elements. This
page contains a rundown of five core perceptual skills of
drawing: they relate directly to the exercises in the next
chapter. You can learn to draw without being consciously
aware of these ways of perception, but you'll be utilizing
them as you draw nonetheless. The more you draw, the
more they will make sense to you.

PERCEIVING EDGES
Seeing boundaries, outlines,
often relating to linear drawing:

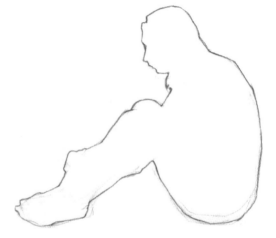

Perceiving relationships (identifying
landmarks on a figure and relating
one landmarks to one another,
important for structure underneath
the drawing):

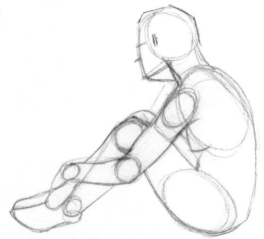

PERCEIVING SHAPES

seeing spaces, shapes, blocks
of tone or color, often relating to
shapes of shadow on the figure:

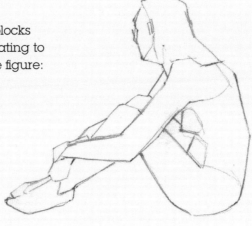

PERCEIVING TONE

Seeing highlights and shadows,
perceiving and comparing values
of light and dark:

Finally, it is important to be able to perceive the whole,
and to see a figure holistically, as a single thing. This is
the most difficult skill to grasp for beginners and builds
naturally along with the others, manifesting in clear
and coherent drawings.

Visual Language

The moment that pencil touches paper all of our perceptual skills come into play simultaneously. It is important to understand that none of these processes are separate—having an intention for your drawing, looking at your subject, perceiving the elements you wish to draw, and making marks are connected and simultaneous activities. Drawing is a holistic skill and the mark-making happens while you are using your perceptual skills to understand the things that you are observing, remembering, or imagining.

Making Marks

Drawing is a visual language that directly describes the visual world. The marks we use in a drawing are equivalent to the words we use in written language. Scribbles, lines, dots, etc. all provide information about the subject they seek to describe and help to create an illusion of that subject on the page. In time you'll develop a complex vocabulary of marks through experimentation, imitation, and practice.

Selective mark-making makes for a coherent drawing; most beginners' drawings contain too many, laid down in a panic. You should never be afraid to make a mark, but when you do, each one should be the result of a clear intention; the skill is in learning to make intelligent marks intuitively. If you can describe something in one line, don't go back over it three times; if you can describe something in 100 lines, don't put down 300.

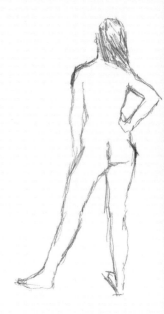

Too many lines.

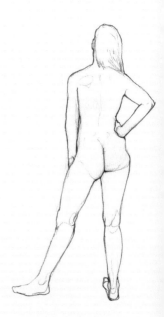

Clarity of line.

Picking the Right Vocabulary

Just as some occupations carry with them their own verbal language (anatomical or medical language used by doctors, engineers talking in terms of forces and materials, etc.) so different kinds of drawings require different visual vocabularies.

Often when a life model strikes a pose, you'll find there is something about the pose you immediately wish to capture and you'll need to pick the right vocabulary of marks in order to describe it eloquently in the time you have for that pose. The head study below aims to capture the line of the profile and texture in the hair, whereas the tonal figure drawing captures the way light creates shapes of shadow on the body. The gestural sketch is the product of a short, dynamic pose and sacrifices accuracy for energy.

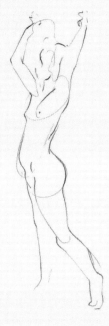

Gestural, linear figure study.

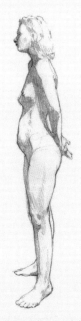

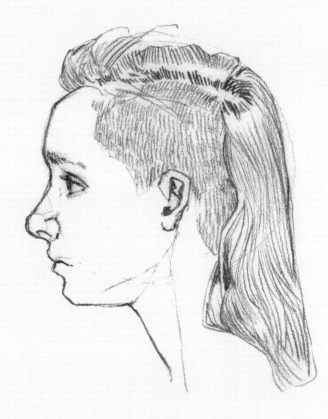

Developed, tonal figure study.

Developed, linear head study.

BUILDING SKILLS

Beginning and Improving

This chapter is all about improving your drawings. You can apply the exercises here to short life drawing poses of around two to five minutes. If you are a complete novice, work your way through one exercise at a time to build a foundation of understanding. If you have some drawing experience, use and adapt the exercises below to hone specific perceptual skills. You'll learn the most by actually doing: draw, draw, draw, and occasionally read something to help you solve a particular problem. Important advice to bear in mind is:

- Spend time looking at the model.
- Make marks with clearer intention.

Improving and Advancing

When you begin drawing, the revelations come thick and fast, and improvement can be swift and easy to recognize. As you become more experienced, the leaps forward are fewer and farther between: little insights that help you draw slightly better. No matter how good you become you'll always have days when you produce dreadful drawings, so don't expect the next one to be better than the last. Use your average work to measure your progress rather than your best and worst work: make many, many drawings, then look back over them after some time and you may get a perspective on your own development.

Practice alone doesn't make for improvement—seek the opinions of peers and teachers to help identify strengths and weaknesses in your drawings so that you can improve on them. You may learn different techniques from different people and some approaches may seem contradictory: try everything, but stay true to your own intentions. Learning to become a better draftsman is a lifelong journey and you'll find that you can assimilate many different techniques into your own way of working.

Internal Tutor vs. Internal Critic

When you begin drawing your progress is hampered by a niggling internal monologue, saying things like:

- "I can't draw faces."
- "That leg can't possibly look like that."
- "This drawing isn't going very well."

This is your internal critic, and it can be more restricting than any lack of ability. To develop, you need time to learn and draw without negative internal criticism, so instead nurture an internal tutor. Turn your self-criticism into constructive questions that you can then try to answer in your drawings:

- "How much higher is the right eyebrow than the left eyebrow?"
- "Is that leg foreshortened? How can I make sense of its shape?"
- "What are the problems in this drawing that make it look unlike the subject? How can I improve on it?"

Give yourself time to step back from your work to ask these questions, and allow yourself to become absorbed in the process of looking and mark-making without criticism. It takes time to learn how to critique your own drawings constructively, but this will come with practice.

Enjoy Drawing

Most importantly of all, enjoy drawing. It can be frustrating at times, and as you improve, your goals will continue to recede away from you. There are myriad subjects, techniques, and mediums to learn about, and you'll never get as good as you'll want to be, so take pleasure in the process of learning.

Seeing Tools

Looking

First look, then draw. Too often the beginner rushes to make marks before properly observing the person they are drawing. Do everything you can to make it easy to observe your subject: make sure you are comfortable and have your materials to hand, and ensure you have as good a light as possible on your model and paper.

Your eye is your most valuable drawing tool—with training you can learn to accurately judge tones, angles, and distances by eye, so practice making your measurements intuitively before resorting to using tools like plumb lines, viewfinders, etc. As you draw, your aim is to establish a connection between your eye and your hand that circumnavigates the intellect, creating a state of flow in your process. You want to look, and make marks in response to what you've seen without having to consciously think about where to put those marks. Your eyes should be constantly flitting from model to paper, paper to model, keeping the dialogue between subject and paper fresh and immediate.

Seeing and Knowing

When you start drawing, you are unfamiliar with the visual world. Just because we spend all day with our eyes open doesn't mean we know how to look. By learning to draw, we learn to see again. Part of the learning process involves breaking down our ideas of how the world looks so that we can actually draw what we see in front of us. First, you should learn to become simply an eye that draws without thinking or rationalizing. As you look and draw more you start to rebuild your knowledge of the visual world to reflect what you've really observed. This is when thinking becomes helpful again. You'll become aware of the anatomy of the body, common shapes in the figure, and of visual distortions like foreshortening.

Visual Naivety

Our brains often stand in the way of clear observation, interpreting visual information in front of you as you try to draw so that you find yourself thinking things like: "an arm shouldn't be that long, so maybe I haven't drawn it right." You should trust your eyes—what you see is what is true for your drawing.

Here's an example: in a body we think of the head as being above the shoulders and the arms being less than half of a person's height. In the first drawing, this is true. In the second drawing, the head is below the shoulders and the arms are almost the length of the whole figure; that is what you'd observe, that is what is true for this pose, so that is what you'd draw.

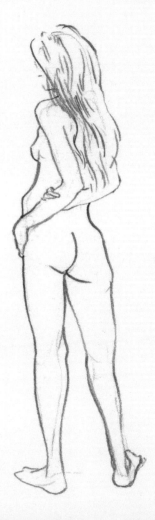

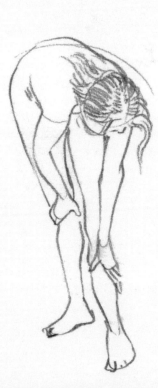

Representation and Likeness

Life drawing is often seen as a discipline that will train you to make realistic, figurative drawings, but what does "realistic" mean? The more life drawing I've done, the more I've come to realize that there is no single reality about the figure to represent, but many. Achieving photographic realism in a drawing isn't the same as making a drawing that truly represents your model.

Drawing and photography are sometimes presented as competing approaches to image-making, but they are disciplines that encompass different skills and fulfil different purposes. A camera captures an objective moment of color and tone, whereas a life drawing is a metaphor for its subject, created over a period of time. When drawing, we constantly move; our eyes change their focus; the model shifts slightly, breathes, stretches. The drawing we make is not of a single fixed view, but of many briefly experienced views of the model and our mark-making can do much more than just record light and dark.

Seeing, Feeling, Responding

When drawing, think about the different facets of the situation and subject you're representing: to what degree is your drawing led by the feel of the environment, by your emotional response to the model or by your own intentions and style? How can you balance your subjective experiences of the model with the process of drawing what you see?

A drawing can be a powerful tool for capturing the feel of a person or a space, a model's likeness and physical gesture, or the draftsman's empathic response to their model. It's hard to define and teach capturing a feeling in a drawing. What you can say about it is that feeling comes from observation and awareness, a sense of empathy in the draftsman, and selectivity in mark-making. A drawing might capture the feel of a person perfectly without being strictly visually representational.

At the extreme end of the scale, life drawings that respond more to emotional observations than visual observations can appear abstract or naïve. The best drawings of this kind are made not by seeking contrived naivety as an outcome, but employing simplification and abstraction as a necessary tool for exploring something beyond the visual.

Something of Yourself

Anaïs Nin said, "We don't see things as they are, we see them as we are." Deliberately or otherwise, you always put something of yourself into a drawing. Some life drawing classes encourage students to take the figure as a starting point for expressive drawing. These kinds of drawings contain a lot of yourself and are often about personal expressions, mark-making and a response to your drawing materials. They shift life drawing towards art-making. This kind of process is great for breaking away from the purely visual and exploring the wider intentions and possibilities of a drawing, as well as allowing you to explore your own creative work.

The Look of the Thing

This whole book is all about developing different strategies for seeing. The feeling and personal expression in a drawing is hung on the framework of your observations.

Mark-making

The marks you make are your way of communicating
with the future viewer of a drawing and are your way of
describing and recording your subject. To help you think
about mark-making, have a look back at the notes on
visual vocabulary on page 32. When working on white
paper with a pencil, you are making dark marks on a
light surface, so you want to look for dark shapes to draw.
The marks also have a role as a metaphorical device so
that as well as communicating something about shape,
outline and tone, they can create an impression of texture,
dynamic energy or contemplative stillness and can direct
the attention of the viewer to a particular part of the
drawing. Think of words that might describe the surface
of the part of the person you are drawing and then think
of the kind of marks that fit the description. For example,
when drawing hair texture, think of the words you might
use to describe the hair you are drawing and let that
inform the marks you make as you draw.

Borrowing Marks

The marks you make feed into the intangible style of your
drawings. They are your handwriting and how you make
them will be individual to you. Borrow marks from other
artists, copy their lines to see how you like them, and
develop your own marks through experimentation. Make
copies to explore other artists' mark-making, like the ones
on the following page.

Smooth, silky hair.

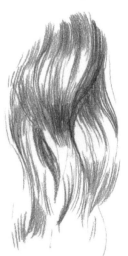

Long, wavy hair.

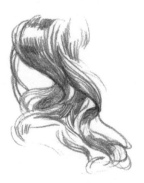

Thick, curly hair.

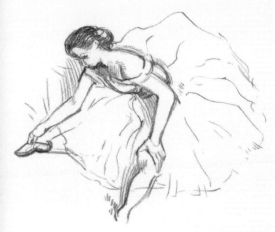

A Degas ballerina: Here I was interested in how Degas' line plays around the figure and her dress, drawing attention to her hair and face with tonal marks and expressing the cloth in capacious sweeps.

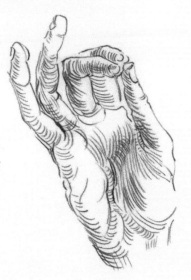

A Dürer hand: Dürer uses contour lines to feel around the volume of the hand, capturing the form using a minimum of marks.

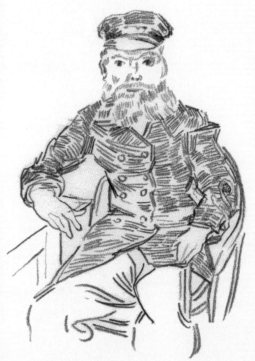

A Van Gogh figure: Van Gogh uses blocks of parallel lines to build up a stylized representation of the figure, saying much about his own style of mark-making in the drawing, alongside representing his sitter.

Making Your Mark

Making marks is a physical thing. Marks that come from the finger and thumb are short and quick. Marks made from the shoulder can sweep and arc and require big paper. As you make a mark, think about where in your body you are drawing from. When drawing at an easel, angle it so that you can see your model and your paper at the same time, adjust it to the correct height and ensure the board is stable so that you can draw without worrying about dislodging it (see page 15).

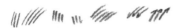

Short marks from thumb and forefinger.

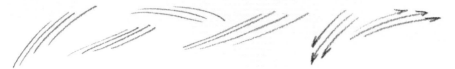

Long, arcing marks from the wrist.

Longer, sweeping marks from the elbow.

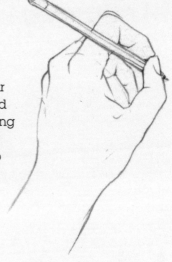

Think about how you hold your pencil as you draw a mark and explore different ways of holding it: are you dragging the point? Pushing it? How does your grip on the pencil affect the mark?

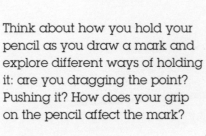

Controlling the point.

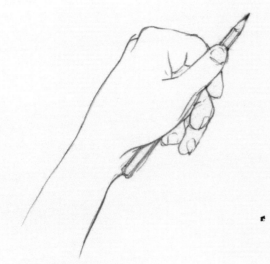

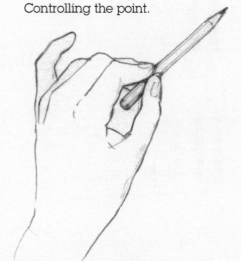

Controlling the side of the pencil.

Dragging a line.

Think about the speed of your marks as you draw them: a quick line has flow and confidence, slow lines can have consistent weight (thickness), and a line lifted from the paper has a directional quality.

For mark-making exercises, go to page 60.

Edges and Lines

Most drawings begin with a line. A line can be a lasso, thrown around an idea or observation in order to maintain control over it and give it initial form. Your first lines help map out your initial intentions and can be edited and improved upon as your drawing develops. We see the world tonally, in terms of light and dark; a line is often an imposed idea that we use to simplify our observations of complex tones. It can represent a boundary between an area of light tone and an area of dark tone: it can represent the boundary between the model and their environment and it can help us select and draw attention to features that we consider important in the figure.

See, Hold, Draw

When making linear drawings from observation you look for an edge, perceive the line in it, and hold the shape of that line in your head for a split second as you transfer it to paper. Be aware of that as you draw: you are seeing a line, holding it in your head, and then drawing it. Then you look for the next line.

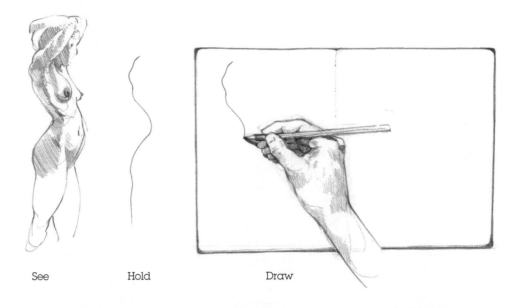

See Hold Draw

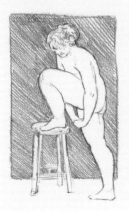

Edges of Objects

To know where to draw a line, you'll need to learn to perceive edges and make decisions about where a line should be drawn to represent that edge. Sometimes this can be obvious: if you have a well-lit model standing against a dark background there is a tonal and a literal edge to the figure. Sometimes it's a judgment call you'll need to make: if there is a gradient of tone, at what point do you draw the line to separate the light area from the dark?

Edges of Tonal Shapes

The first drawing shows a dark shape on a light space; there is no actual line between the two, just an edge between tonally contrasting areas. In a different drawing of the same subject, a boundary between these areas of light and dark tones could be described by a single line.

In the third drawing you see a light background and dark shape on the left of the sphere, and on the right it's a light shape with a dark background. This contrast gives the illusion of three-dimensional form.

This arm shows a gradient of tone across it. As well as having it's own object boundary, the arm has shapes of tone within it that in turn have their own edges. When you draw these shapes you might find it helpful to start with a line around them, even if that line disappears into the tone later. You'll need to make a decision about exactly where you put that line: it's down to your judgment.

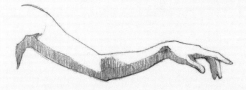

A Line for a Line

Weight of a Line

Sometimes a long, thin shadow creates a perceived line on the figure. A drawn mark can represent that line simply and directly. Look at whether the shadow varies in thickness and think about how heavily you should press your pencil on the paper to replicate it, and if that pressure should vary. We call this changing pressure, width, and tone "weight of line."

Also think about how you are holding the pencil (see also page 43), as this will affect the kind of mark you make. Holding it vertically above the paper so that the point goes straight down will make a fine line, whereas holding the pencil at a low angle close to the paper will naturall give a thicker line.

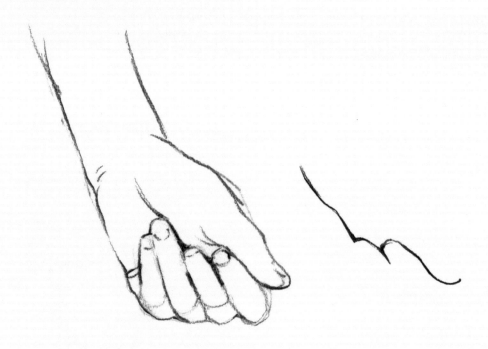

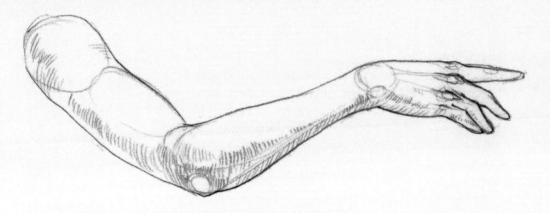

A Line around an Idea

A line doesn't always have to be tied down by tonal representation; it can also help to reinforce an idea in a drawing. You can use lines to hint at what is below the surface of your subject, skirting around muscular and skeletal shapes below the skin or suggesting the curvature of a surface by contouring over it. Experiment with using the line to mirror your observations, traveling lightly over your paper as your eye travels around the model, adding more pressure and focus to areas you wish to draw attention to.

For a lines-and-edges exercise, go to page 66.

Relationships and Points

A drawing is made up of marks arranged on a page. It is important to develop an understanding of how shapes and points sit together in context with one another to reflect the relationships you perceive in your subject. Problems in proportioning the figure usually derive from mistakes made perceiving the relationships between one part of the body and another. If you spend time looking for and isolating landmarks while drawing, you will train yourself to see them more clearly and identify them quicker.

A Bridge between Points

As soon as you make two marks on the page you create a space between those marks; lines can be drawn to bridge that space. When you are identifying the relationship between points on the figure, you'll want to think about what kind of line should join those points. You might make a convex line or a concave line; it could be made slowly or quickly; it could run straight or curve back on itself; it could be broken or continuous. Look at where the line will start and where it will end before you make it. Keep observing, and keep the process fluid and intuitive.

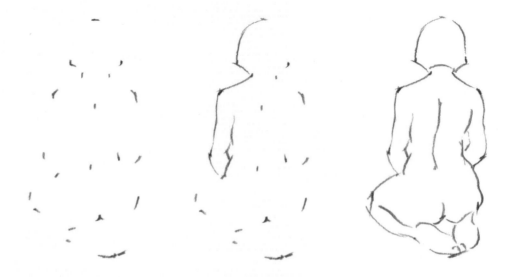

Stage 1, Stage 2, Stage 3.

Relationships between Shapes

As well as looking for relationships between points you can relate one shape to another across a figure. It is often helpful to look at the broad relationships between shapes of a similar kind. For example, you could look at how all of the shapes of mid-tone shadow are positioned on a figure and try to perceive their relationships: is one shape at a diagonal to the other shape, or are they horizontally aligned? You might also look for relationships between landmarks: is one knee higher than the other knee? Think of these groups of shapes like constellations of stars spread over the figure—you want to work out how they all join up to create the illusion of a figure on your paper.

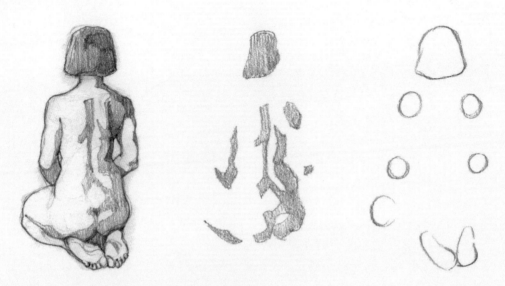

Original subject; shapes of shadows; landmarks.

Tangents

The human figure is bound by convex or concave lines joined together in flows; there are no straight lines. However, rather than getting caught up in the undulations of the figure it can sometimes be helpful to simplify the body into straight lines by looking at the average line of a curve. This might mean looking for a tangent that touches the edge of a curve, or a line that cuts through one, traveling between two points. Imagine you are a sculptor cutting away at a block of marble. To find the figure underneath, you have to rough out the general form.

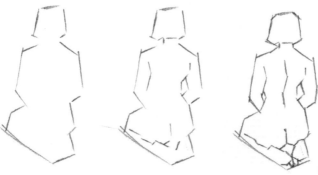

Stage 1, Stage 2, Stage 3.

Horizontals and Verticals

Vertical and horizontal relationships can be the easiest relationships to judge and measuring tools can be used to make comparisons easy. Have a look at page 58 for examples of observational measuring. When you place a new mark, check if it should be above, below, to the left, or to the right of other marks you have drawn.

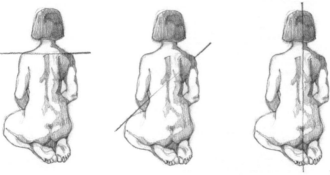

Horizontal, diagonal, vertical.

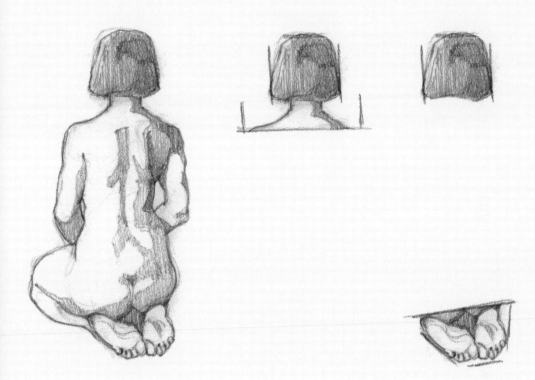

Original subject, close relationship, distant relationship.

Close and Distant Relationships

When you place a new mark on your drawing, you tend to think about how it relates to close neighboring marks. Make sure you simultaneously check how it relates to more distant points. This will help the drawing develop as a whole, rather than in disparate parts. It might be helpful to have a single point, established early, that you refer back to every time you place a new mark.

For a relationships-and-points exercise, go to page 64.

Shapes and Spaces

Seeing shapes in the figure is about simplifying something complex. A person can be simplified into an arrangement of geometric shapes and a complex gradient of shadow can be broken down into simple shapes of different tones sitting next to one another like jigsaw pieces. A shape is a set of points joined by lines to give it edges, so seeing and drawing a shape relies on previous perceptual skills. Two kinds of shape are particularly useful in life drawing: underlying shapes for constructing the figure, and tonal shapes for the surface of the figure and negative spaces.

Underlying Shapes

You can use simple shapes to underpin general forms in the figure. Imagine you are making the figure from clay; first you might build up big blocks to establish a general shape before cutting clay away or adding more to define the form. As you look for these underlying shapes think in metaphors: is the pose spire-like and triangular? Is it square? Is the figure curled into a ball?

Big Shapes to Smaller Shapes

Once you've established a big, general shape on the page, look for smaller shapes within it. Keep the sculptural idea in mind; you are chopping shapes off the basic form and adding extra shapes to make the drawing on your paper look more like the figure you see in front of you. Work from big shapes down to small ones, refining the form gradually rather than getting caught up in detail early on.

Tonal Shapes

Tonal shapes are the simplified shapes of shadow and highlight by which we perceive the surface of the figure, touched upon earlier in this chapter. When you're drawing with a dark medium on a light surface you tend to look for shapes of shadow, because it's the dark shadow that you'll actually draw. Maintain an awareness of the highlight shapes at the same time. All the shapes should fit together to make a visual jigsaw; all you should need to do is to draw each shape as you see it, with the correct tonal value and in the correct place. Shapes outside of the body—the negative spaces that represent the background—can also be seen as light or dark shapes that fit together around the figure to help define the body.

For a shapes-and-spaces exercise, go to page 68.

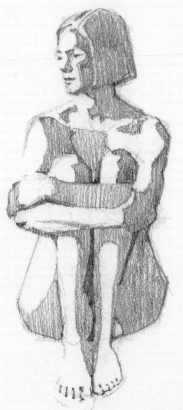

Simple shadow shapes.

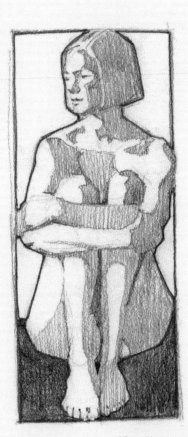

Negative spaces.

Light and Tone

We see the world by perceiving light, and everything we see can be understood as having color and tone. We think of color in terms of a spectrum of hues: red, orange, yellow, etc., but in a monochrome drawing everything needs to be simplified to tonal values. Think of tone as the grayscale in a black-and-white photograph. It is not the same as color, although colors have tone; you can practice recognizing the tones of colors by imagining them photocopied in black and white. Tone is also referred to as "value."

Light falling on figures sculpts shadows onto them; the shadow is created by the interruption of light by forms. While line is an imposed idea used to simplify an edge, direct tonal drawing reflects how we actually see the world by using a map of shading to create the illusion of the figure on the page. Tone can be used selectively to give drawn surfaces curvature, and figures a sense of three-dimensional form.

Recognizing Relative Tones

Tone is seen as a gradient, merging from light to dark. To represent these gradients of shadow, you'll need to simplify them. Train yourself to group the varieties of tones you see into dark mid-tones, mid-tones, and light mid-tones, and practice mark-making techniques for those different bands of tone in order to become better at looking at, identifying, and producing them quickly. Beginners tend to make shadows overly dark; the visual world is mostly mid-tone punctuated by relative darks and lights.

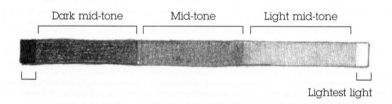

Dark mid-tone Mid-tone Light mid-tone

Lightest light

Tonal Range

The materials you use set the potential tonal range in your drawing. The darkest dark you'll be able to achieve is at one end of the scale and is made by pressing the pencil hard against the page. The lightest light is the white of the paper and sits at the other end. Different grades of pencil will give different tonal ranges, with the darker Bs giving a wider total range, and lighter Hs yielding subtle differences within a narrow tonal range. Start with several grades of pencil and experiment with them to work out their ranges and which grades you prefer; you might find you prefer to use just one grade for ease and simplicity, or several grades for broader tonal range and greater subtlety.

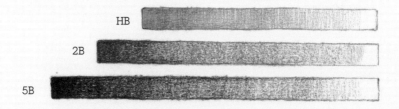

Comparing tonal gradient of a 2B pencil with a 6B pencil.

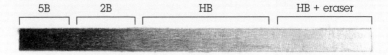

Using three grades of pencil for full tonal range.

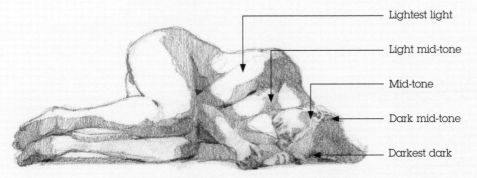

Figure drawn with simplified tone.

Seeing People as a Whole

An awareness of "the whole" is the most difficult perceptual skill to explain. It generally develops as your drawing improves. Essentially, it's important to be aware of the figure as a whole, even as you are drawing the smaller components that go together to make up the human form. As you look and draw, you want to "zoom in" to specific details to to tap into the finer proportions of the figure, and then "zoom out" again to appreciate the overall form. If you only work from one part of the body to another, you'll tend to slip out of proportion over the course of the whole drawing, so that by the end you may have lost the top of the head off the page, feet off the bottom, or had the head fall out of proportion with the torso, and so on. If you notice something going wrong, correct it immediately; it is better to establish good habits than to preserve disparate elements of the drawing. It is always ok to allow a drawing to distort if that is your intention, but remember that stylization isn't the same as incompetence.

Objective Analysis

It can be difficult to see a drawing objectively when you are
in the middle of making it. In order to identify the problems
in a drawing and make decisions about how to improve it,
you'll need to find a way to look at it afresh. To help you
spot problems in the drawing look at it in a mirror, or turn
the drawing upside down. Distance will also help; if you
are sitting down, hold the drawing out at arms' length
and compare it to the model, flicking your eyes to and fro
between the drawing and the figure. If you are at an easel,
take a couple of steps back and do the same.

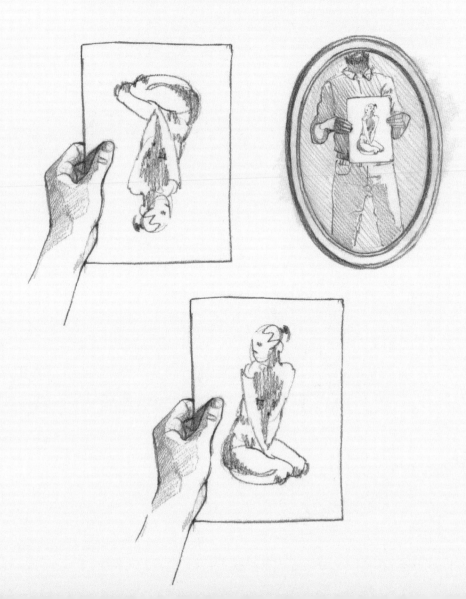

Observational Measuring

Although intuitive visual measuring is always the ideal, you'll find that at all stages in your drawing education there will be times when you can't quite judge a distance by eye. That is when you can introduce observational measuring tools to help you judge what you're looking at and make accurate comparisons.

Measuring with a Pencil

Have you ever seen an artist squinting down their outstretched arm, pencil held up in front of them? This is what they are doing. Hold your pencil at arms length (to keep the measurements consistent), close one eye (to flatten what you see), and put the top of the pencil against one edge of the subject you want to measure. Slide your thumb down the pencil to line up with the other end of your subject. You now have a distance that you can compare to other parts of the subject. This approach to measuring makes you look extremely arty—but don't get carried away; it's best to only use it for checking proportions you can't judge by eye. Here are some examples of how to use the measurements.

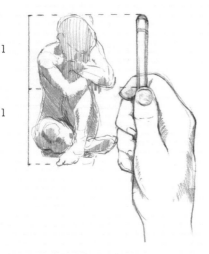

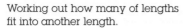

Working out how many of lengths fit into another length.

Comparing a length to a width.

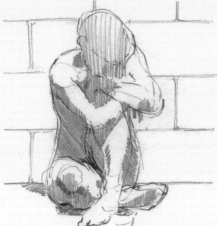

Verticals, Horizontals, and Diagonals

You can use your pencil to check angles in your drawings and to establish horizontal and vertical relationships across a picture.
A plumb line (string with a weight on the end that hangs vertically) can be used for the same task.
You can use also use vertical or horizontal objects in the background to compare against your model.

Checking a horizontal.

Comparing a diagonal.

Exercises

The next few pages contain practical exercises you can use in life drawing classes. Each exercise relates to the core skills of drawing described earlier in this chapter. Below you will find details of all the materials required for the exercises.

What You Need

🕐 2-15 minutes

Pencils
Eraser
Sharpener
Ballpoint pen
Charcoal
Sketchbook
Drawing board
Paper

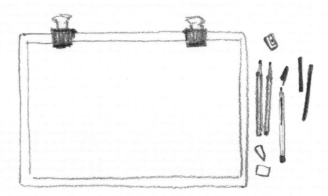

The exercises can be adapted to suit many different drawing materials. You could simply use a pencil and sketchbook, or paper and charcoal, or any permutations of the materials suggested above. You could branch out into using any other materials you'd like—look back at Chapter 3 for suggestions. All of the examples here are drawn in 2B pencil for simplicity.

Set up your easel, or drawing board, or sketchbook-in-lap: whatever is comfortable and suitable for the class. Make sure your materials are to hand and you are ready to draw before the first pose begins.

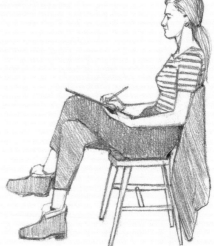

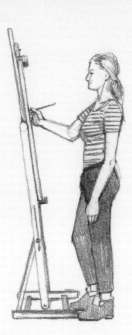

Using the Exercises

All of these exercises are intended for use in a life drawing class. Many classes will start or end with several short poses; this will be an opportunity to try them all out. Take this book with you, and read through the exercise before you start. Then draw several poses using the same technique; some drawings will work better than others. Think of it as a warm-up—the drawings don't need to come out looking good, because they are intended to help you practice specific skills that you can then relate to a longer drawing. If you want to practice these exercises during a longer pose just time yourself and make short, repeated studies from one position, or move around the model every few minutes making a new drawing from each angle.

Applying Them Outside of a Life Drawing Class

If you're not in a life drawing class but still want to practice, find a friend who will pose for you (see Chapter 7) or take your sketchbook outdoors to find people on the street to draw. People tend to stay still at bus stops, in cafés, and on public transport. Trying making very quick sketches of moving people on the street or at the park. If you're worried about drawing alone, go sketching with a friend; draw one another and, if you feel brave enough, both draw other people around you together—it will take some of the pressure off.

Exercise: Eloquent Scribbles

These three exercises will help you explore mark-making. While the life model is getting into position, you'll have a few moments to practice making marks before a pose begins. Fill a spare sketchbook page or the corner of your paper with mark-making warm-ups. Use the same medium you intend to use in your first drawings.

METHOD 1: A SERPENTINE LINE

Practice drawing a line. It seems basic, but it's well worth 30 seconds of your time. Quickly make two dots on the paper and without thinking or hesitating, join them with a line. Dot, Dot, Line. Repeat it and improve on it. Explore line weight by pressing hard, then lighter, and explore different holds of the pencil from page 42. Now imagine you are drawing the serpentine S-shape of the spine.

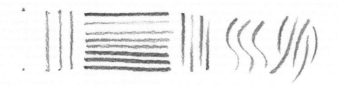

METHOD 2: TONAL GRADIENT

Practice your tonal mark-making. Make hard, dense marks on the page to achieve the darkest dark that you can and extend that across the page in a gradient of marks that become increasingly lighter until you reach the white of the paper, your lightest light.

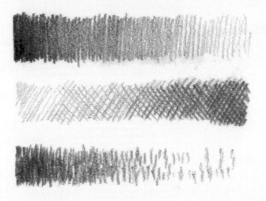

METHOD 3: CONTRAST AND VARIETY

Contrasting marks make for interesting drawings. Use one style of mark-making to lay down a block of tone, then selectively make different kinds of marks next to and over the top of your first marks. Explore abstract relationships between different kinds of marks and about think how this can be applied to your figure drawing to create engaging tensions between the different textures on the page.

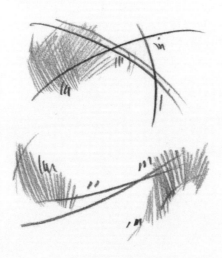

Exercise: Blind Contour Drawing

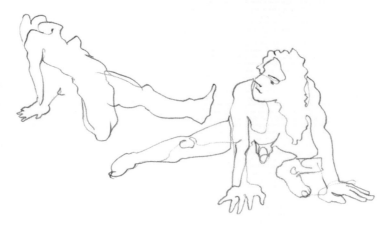

This is a commonly used exercise to help you make clear observations, unrestricted by the worry of how the drawing looks. It will also help you to see edges and make decisions about where to draw a line. Finally, it encourages confident linear mark-making. You'll need a material that doesn't smudge easily: pencil or pen is ideal.

Method

Secure your paper and sit looking at the model; don't look at the paper at all throughout this drawing exercise. Touch your pencil to the top of the paper, and focus your eyes on the top of your model's head. Don't look down at your paper. Slowly, let your eye trace a line over your subject. As your eye follows its way across the surface of the subject, let your pencil follow the same movements on the paper.

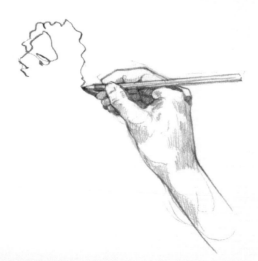

Draw a continuous line around your subject's outline, moving inward to draw around shapes and shadows, constantly looking for lines to represent. If you lose your place you may look down at your drawing once, reposition your pencil, and continue the process again, keeping your eye on the subject while drawing at the same time. When the time is up, lift your pencil off the paper and take a look at what you've drawn. Expect the drawing to appear bizarre and disproportioned; after all, you weren't looking at it! Repeat regularly to help you get used to looking and drawing.

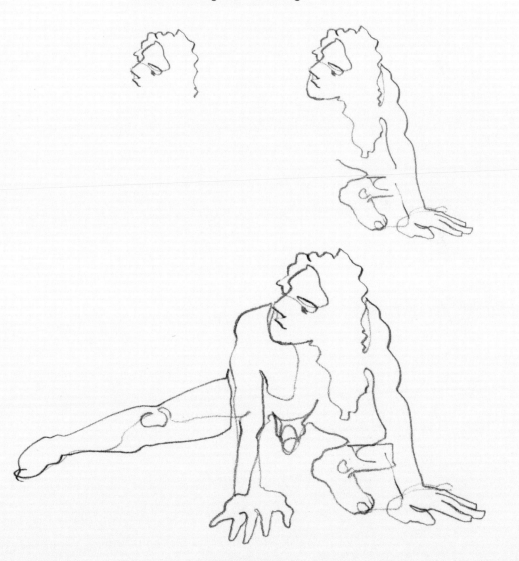

Exercise: Sculpting the Figure

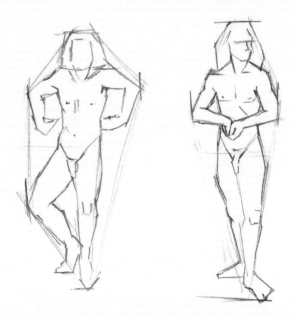

This exercise is about simplifying complex forms, using tangents and average lines to find key shapes in the figure. It will help you to simplify the complex curves of the body, blocking out an overall shape which can be worked into later. You will be working like a sculptor, roughing out an initial form and chipping away at detail.

Method

Mark the limits of the pose; the top, bottom, left and right extremities. Imagine the walls closing in and ceiling coming down to meet the extremities, what part of the pose would they touch first? This is your initial block that you are "sculpting" from. You might also want to mark the mid-point of the pose.

Work your way around the outline of the figure, drawing only in straight lines, aiming to find the average line of curves and paying attention to changes in direction of average lines in the body.

Once you have drawn a blocky outline, then work into the center of the form, imagining all the while that you are sculpting the figure from wood and chiseling sections away to get to the detail.

Exercise: Tiny People

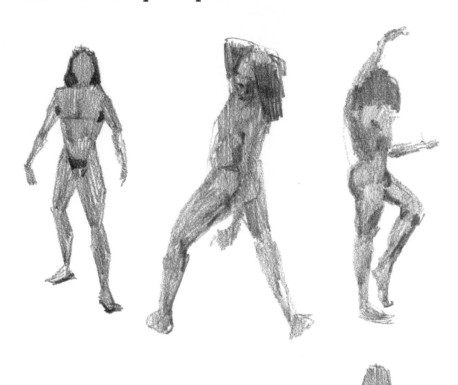

This exercise will encourage you to look for blocks of shapes; first the overall figure, then shapes of shadow on the body. See the figure as a whole shape in space and free yourself from concentrating on detail.

Method
Your drawing will be small: the length of your thumb or slightly larger. This will help you control the marks and get the whole figure drawn in a short pose. First draw the overall shape the model makes in space, as if you were drawing their silhouette. Using consistent vertical, diagonal, or horizontal blocks of tonal marks scribble in the shape of the figure on the page. As you draw, be aware of shapes: both in the body, and the negative spaces around it. Even if you see the figure as light, draw a consistent mid-tone; you are just looking for shape.

Once you have scribbled in the basic silhouette, use shapes of harder, darker marks to represents any dark blocks of shadows you can see, and any edges and lines that might help to clarify the form. Unfocus your eyes to make it easier to generalize the tones. Keep it quick and simple. Don't get caught up in details.

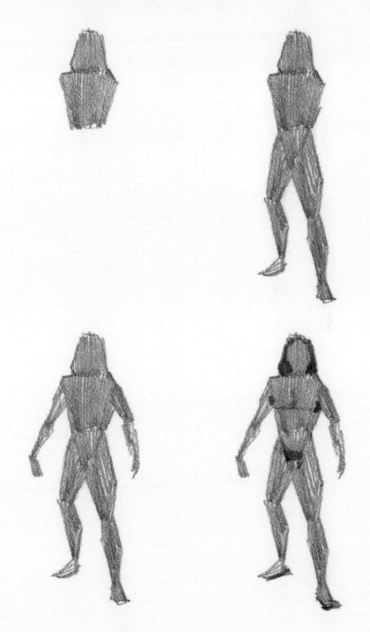

Exercise: Subtractive Tone

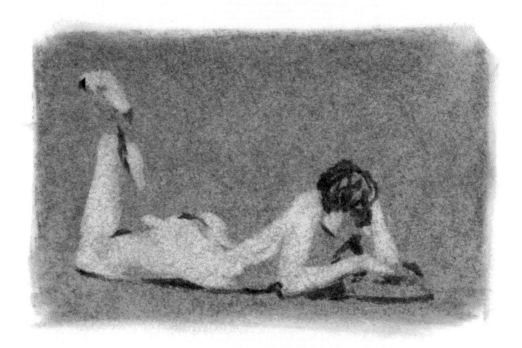

This exercise will help you recognize and draw shapes of tone. You will need a material that can create blocks of tone quickly and can be easily erased to create light shapes. Charcoal or graphite powder is ideal.

Method
Prepare your paper by lightly rubbing charcoal or graphite powder into it with a cloth. Don't scrub it in too hard but aim to cover the surface with a mid-tone of gray.

Taking a good plastic eraser cut to a point, start drawing in shapes of light. Start from a clear shape of highlight and erase areas of light as you see them, staying aware of the relationships between shapes. You are drawing the shapes of highlight, leaving the mid-tone shadows behind. Keep the marks quick, simple, and blocky.

Once you have drawn in simple blocks of light, quickly draw in your darkest darks, to give the drawing clarity and focus.

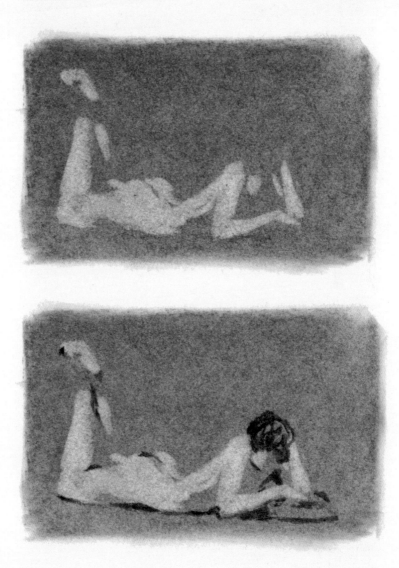

THE 15-MINUTE FIGURE

The Basic Figure

This chapter focuses on using layered drawings to create a figure sketch in around 15 minutes; the approach used in this chapter can also be applied to any length of pose over 15 minutes long.

Long, laborious drawings don't necessarily come out looking better than quick drawings—quick drawings can make for very engaging images. If you're clever with your drawn selections, the fewer marks you put down, the more accurate a sketch can appear, as the viewer is left to fill in the gaps. The longer you spend on a drawing, the more accurate you have to be to make it convincing. The advantage of making a longer study is having more time in which to reassess and re-draw parts the figure, having more time to focus on details as part of a complete study, and being able to render the surface of the figure with a greater degree of finish.

Poor time management is often mistaken for poor drawing. For example, somebody might think they can't draw hands—the problem might not be that they lack the skills so much as they always add hands in the last 30 seconds of the pose rather than making the time to properly study them. Think about how much time you put into each part of the figure when you draw. Are you managing your time to suit the intentions of your drawing?

A Visual Conversation

When you draw somebody from life, you can think of the process as being similar to meeting them for the first time. At first you take in their overall shape and appearance, then you might engage with their eyes, and finally your gaze might move around the rest of their face and their hands to take in their expression and gestures. By following a similar approach in your drawings (sketch a general impression, then hone in on features and details) you follow a familiar and rehearsed way of seeing people.

It's important not to leave hands and faces out of a drawing unless you have a good reason to. They represent the essence of your model's identity—a figure without hands and face is just an anonymous torso. If you're afraid to approach any part of the figure, use the spotlights in Chapter 6 to help you. Remember, just draw the shapes you see in front of you, and by working visually, you can break the figure down into a simplified collection of lines and shadows.

Intention

Every drawing you make should be driven by some kind of intention. You'll want to know what your drawing is about so that you can direct your process to create a coherent study. You don't always have to draw a full figure, but you might want to make a focused study, draw a portrait, or even sketch the entire room and situation. The life model is your starting point; after that work out what inspires and interests you, and allow your drawing to focus on that.

A complete figure.

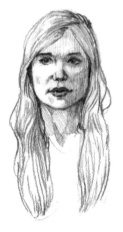

A portrait.

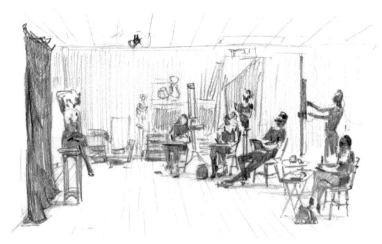

The life drawing class.

Establish, Construct, Elaborate

This approach to observational drawing can be applied to any subject; the idea of the three stages is to give you time to deal with one aspect at a time. Erasing between the stages is important, not to get rid of what you've done, but to push back your marks to make way for the next layer. By working in layers you'll be able to think about one problem at a time in the drawing and then push the layer back, using the success of the underdrawing to aid the next layer while correcting any problems in the observation. It allows you to keep your marks fresh and to look your way through the whole subject several times. Here are the stages broken down: the rest of the chapter will lead you through each in more depth.

Establish

At this stage you should aim to make a quick, intuitive response to the subject. It's an opportunity to observe the whole subject without getting caught up in detail or careful proportioning. Look for flows, gestural lines, and big shapes. Keep your hand loose and draw quickly.

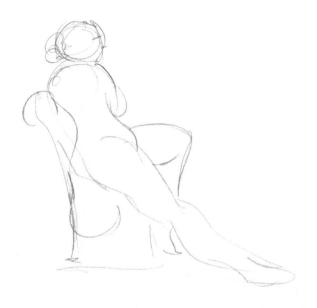

Construct

Building on the establishing sketch, you now want to map simple geometric shapes in the figure. This is where you firm up the proportions of your subject. As you find inaccuracies in your previous, partially erased sketch, just erase them further and draw over them. Work quickly, lightly, and confidently, and pay particular attention to the relationships between different parts of your subject. It doesn't need to look pretty as this is a stage to help you solve problems.

Elaborate

Elaborating on the previous underdrawings means looking more at the surface, and putting down the final lines that will represent your model. Remember the energetic marks of the establishing drawing and build on the accuracy of the constructed drawing. Trust the proportions of the past layers, but if you come across inaccuracies that you want to improve upon feel free to erase and redraw that area. It can help to first think about line, clarifying object outlines and shapes of shadow. Then look for tone, separating shadows into light and dark mid-tones. Finally, think about your darkest darks and lightest lights, using a darker mark to selectively deepen shadows and using an eraser to tidy up edges and bring out highlights. You can take this stage as far as you like. It is important to learn when to stop.

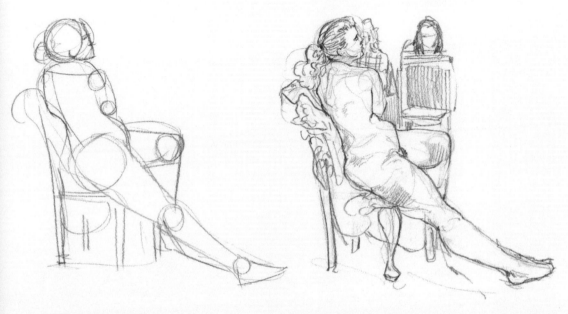

Stage 1: Establish the Pose

The establishing sketch is a fast, gestural drawing that helps you break the white of the paper and make a few early marks before committing to a solid form. It's an excuse to look, and it will force you to properly observe your subject. As you draw, make sure you look at the model more than you look at your paper. Establishing sets the scale of your drawing; it ensures you get a holistic impression of the pose, and can stop you falling out of proportion as you work.

What Skills Does It Use?
- The establishing sketch requires holistic observation of the pose. It's about seeing big shapes and outlines in the figure and jotting those shapes down straight from your eye.
- It particularly requires you to see the edges of shapes of shadows and outlines in the figure.

🕐 10 seconds–1 minute

How to Improve
Making quick, gestural linear drawings of short poses will help you improve your establishing sketch. Practice the "Blind Contour Drawing" exercise in Chapter 4.

ESTABLISH

A: GESTURAL SKETCH

B: ERASE

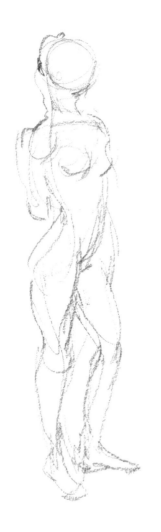

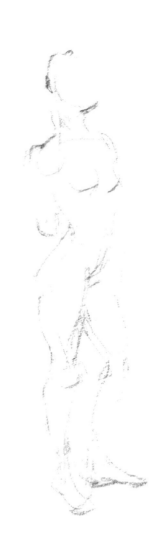

Stage 2: Construct

The construction drawing involves laying down a scaffold of shapes that underpin the model's pose. Sometimes these shapes are purely visual (shapes of shadow and negative spaces) and sometimes they relate to set landmarks in the body (joints and big underlying shapes like the skull or ribcage). This layer of drawing provides a structure on which to hang your observations of the figure's surface. As with the previous stages, the lines are laid down in order to be erased later—you might want to erase the construction lines completely, or allow them to show through in the later stages. As with all the instructions here, adapt it to your needs and preferences.

Drawn Anatomy

The simplified framework used to construct the figure gestures to the anatomy underneath the skin. Putting down this constructed under-drawing is like building the figure up from its drawn anatomy—not quite drawing the bones and muscles of the body but outlining shapes that hint at them. When using these structures, be careful not to become too formulaic; they are a way to create a framework for your observations and shouldn't replace the truth of what you see. The first layer of construction involves identifying landmarks joined by tangents; the second layer involves finding flows in the body that relate to the connecting musculature.

What Skills Does It Use?

- Knowledge of human anatomy can help at this stage.
- Perception of the relationships between shapes, and the ability to recognize those shapes.

🕐 3–5 minutes

How to Improve

Study basic anatomy to help you identify landmarks in the figure and develop a holistic understanding of bodies; practice the "Sculpting the Figure" and "Tiny People" exercises in Chapter 4.

How landmarks relate to the skeleton.

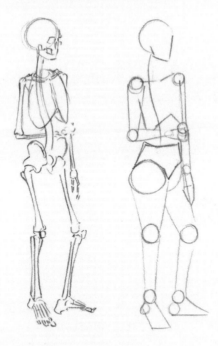

How flows relate to musculature.

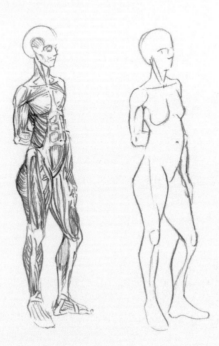

Landmarks

This first part of the construction stage relates to the
structure of the skeleton, using circular shapes over joints
and tangents to suggest the straightness of bones without
losing mass in the figure. Core shapes like the ribcage and
skull provide anchors for the drawing, as does the pelvis,
simplified by joining the edges of the iliac crest and
greater trochanter of the femur to create a shape not
unlike underwear. This makes for a rigid, mannequin-like
core, and is the stage at which key proportions will be set
in the figure.

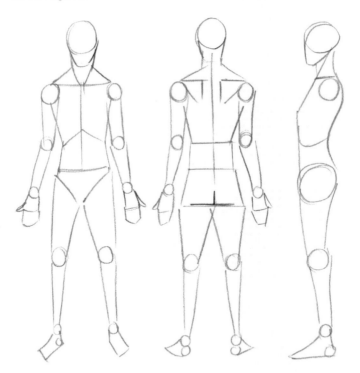

Common landmarks to look for.

CONSTRUCT (LANDMARKS)

A: LANDMARKS B: TANGENTS

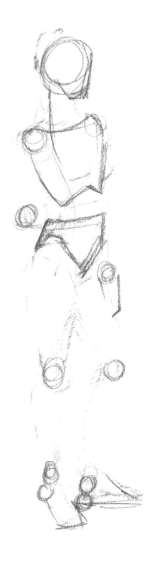
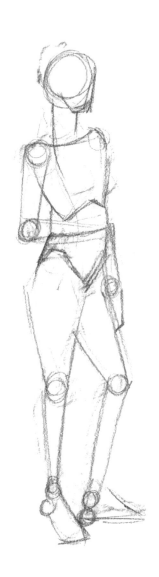

Erase

Flows

The human body is made up of flowing concave and convex lines. To avoid the drawing becoming rigid you'll want to join the core landmarks with flows that represent muscles, fat, and skin. When you are looking for these curved flows on the body remember that the body is three-dimensional—the edge that you are drawing is a horizon line that is disappearing around the other side of the body. The flows will be very individual to the model and the pose, much more so than the more rigid skeletal structures. These flows will supersede the tangents of the previous pose and you could easily skip the tangent stage and join landmarks directly with flows.

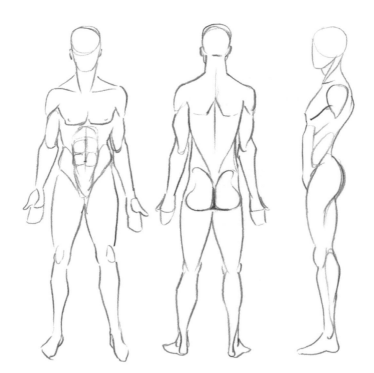

Common flows to look for.

CONSTRUCT (FLOWS)

C: BIG FLOWS

D: SMALLER FLOWS

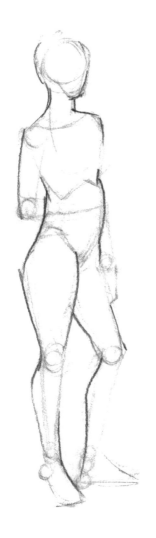

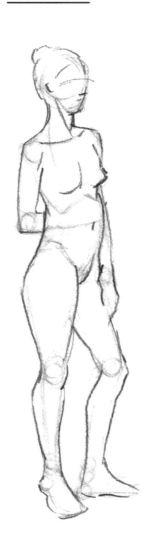

Erase

Negative Space

Negative spaces are the shapes around your subject that aren't a part of the subject itself: the spaces between limbs, or between a figure and its environment. If you think of your drawing as a jigsaw, you could imagine that as well as a person-shaped piece there are many negative spaces pieces too that fit around the person to make up the rectangle of the paper. Seeing negative spaces around a figure will help you during the construction stage, particularly if you're having trouble working out how to draw a part of the body.

What Skills Does It Use?
- The ability to recognize abstract shapes as well as perceiving the relationships between shapes.

1–2 minutes

How to Improve
Practice looking for negative spaces around and between objects—you can use a viewfinder (a piece of paper or card with a rectangle cut in the middle) to help you recognize shapes around the body.

CONSTRUCT (NEGATIVE SPACE)

E: INTERNAL NEGATIVE SPACES

F: EXTERNAL NEGATIVE SPACES

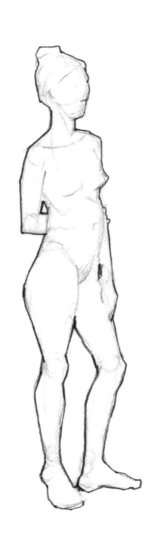

Problem-Solving

If something doesn't look right in your drawing, this is the best time to change it. Even if it means erasing most of what you have done to find the correct line it's important to get into good habits. You'll need your internal tutor here (see page 34), as this is a good moment to hold your drawing out at arms length and compare it to your subject: does it feel right? Does anything need changing? What other problems can you identify?

How to Check for a Problem
The most effective ways of checking for problems are ensuring that the negative spaces appear to be the correct shapes, and checking the correct parts of the body line up with one another along vertical and horizontal lines (see page 58). Check the drawing against your subject, then identify where any problems may be, erase those areas and redraw them more accurately. If you have trouble seeing the problems, explore different ways to view the drawing objectively (see page 56).

CHECK: SPACES AND SHAPES

CHECK: VERTICALS AND HORIZONTALS
Make changes if necessary

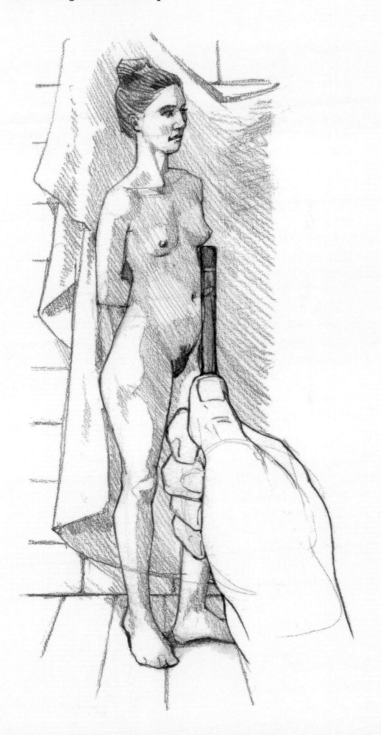

Stage 3: Elaborate

Elaborating on the drawing means drawing the things that you actually see on the surface of your model: the light and shadow, and the actual outline of the figure. Work out what you want to include, how much detail you want to go into, and layer that over the top of your semi-erased construction drawing. This is the stage where you can exercise considerations of design, deciding what will look best where, and whether you want to make the drawing tonally representative, linear, or to stylize elements of it. As you build on the earlier layers with the final stages of drawing remember the energy of the first establishing sketch—the marks you make now should be better placed and more considered, but no less energetic.

What Skills Does It Use?
- Shape recognition for drawing shadows and comparison of tone for the light and dark.
- Perception of edges and outlines.
- Decision-making and design plays a large part, involving selection and imagination.

◑ 5–10 minutes

How to Improve
Improving at this stage is partly about developing your own style of drawing. Practice mark-making that you find pleasing, and work out what it is you want to express in your drawings. Just knowing when to stop is one of the greatest skills you will learn.

A: ELABORATE ON LINE

B: ELABORATE ON TONE

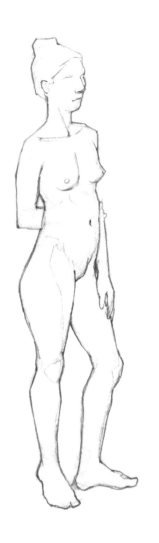

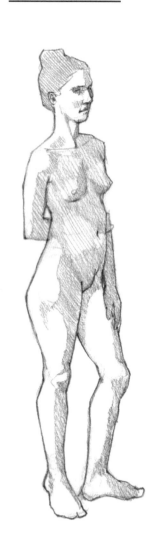

C: LIGHTEST LIGHTS AND DARKEST DARKS

D: THE FIGURE'S ENVIRONMENT

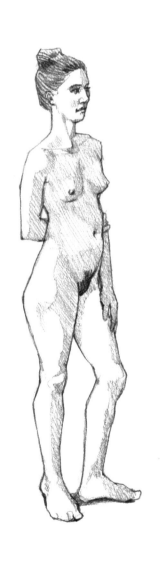

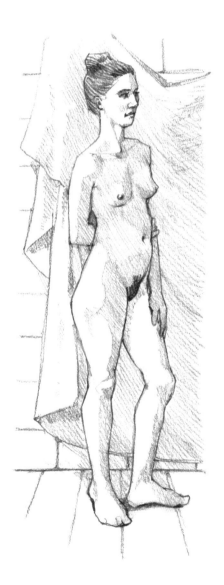

THE FINISHED DRAWING

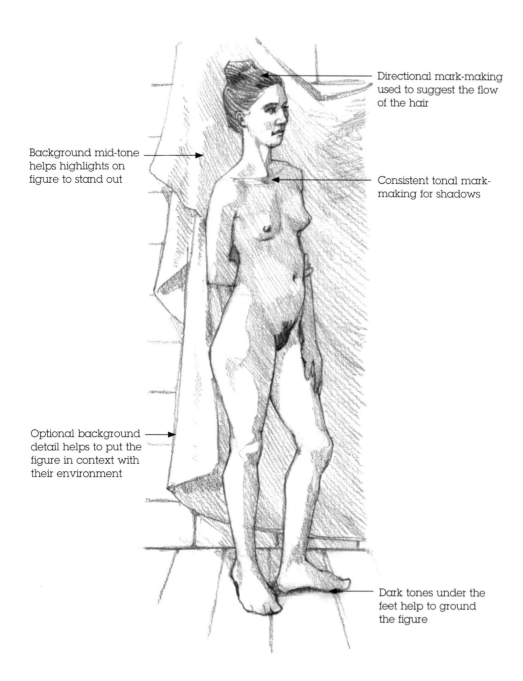

Directional mark-making used to suggest the flow of the hair

Background mid-tone helps highlights on figure to stand out

Consistent tonal mark-making for shadows

Optional background detail helps to put the figure in context with their environment

Dark tones under the feet help to ground the figure

Putting It all Together

Here is the whole process as step-by-step drawings.
Use it to refer to, and then practice it yourself.

Remember: Look.

STAGE 1

ESTABLISH

A: GESTURAL SKETCH

B: <u>ERASE</u>

STAGE 2

CONSTRUCT

A: <u>LANDMARKS</u>

Think about anatomy!

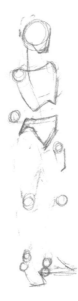

B: TANGENTS

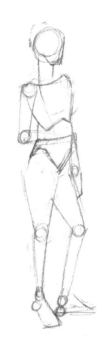

C/D: BIG FLOWS

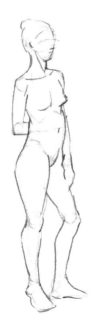

E/F: NEGATIVE SPACES

Problem solve

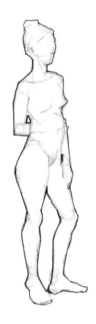

Check, erase and re-draw if needed!

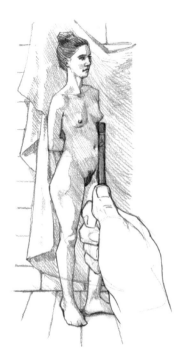

A: ELABORATE ON LINE

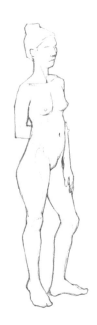

B: ELABORATE ON TONE

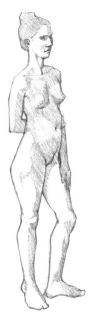

C: LIGHTEST LIGHTS AND DARKEST DARKS

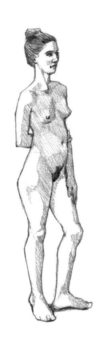

D: ENVIRONMENT

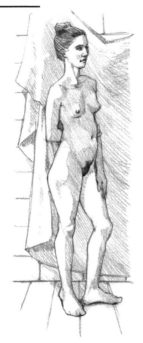

Exercise: 15-minute Pose

Aim

This exercise will help you get to grips with the process of establishing, constructing, and elaborating from a model. You will need the same materials and setup described on page 60.

Method

With practice this approach can be easily applied to 15-minute poses, however, at first it might work better for 20-minute poses or even longer. Aim to stick to the stages suggested rather than drawing as you might normally draw and work through each step, keeping an eye on the time as you do. Set yourself up comfortably before you begin, making sure you can see your model and paper without having to move your head too much. Decide at the beginning whether you're going to do a full figure study, a partial figure, or a portrait and stick to this intention.

Stage 1: Establish
Look

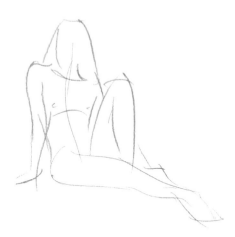

Stage 2: Construct
Erase

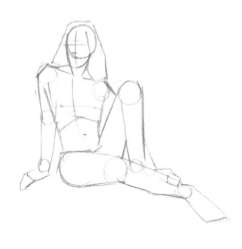

Stage 3: Elaborate
Erase

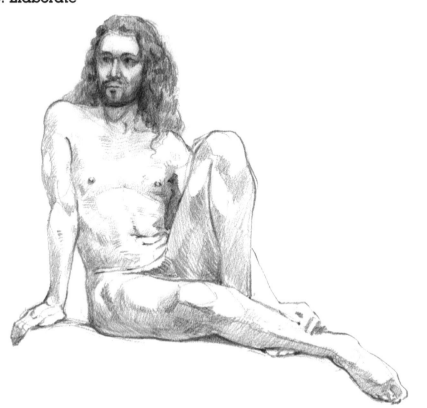

GOING INTO DETAIL

Hands

Hands are very important to the gesture of the pose and, along with the face, create a sense of the model's identity. It's easy to draw hands too small—they are often larger than you think. When you are drawing the hand as part of a full pose, you might only have a minute or even a few seconds to sketch it out in the time you have. Look at its overall shape and break down the form. If you have no time to get into detail, draw it as a simple block, paying attention to the position of the wrist, knuckle line, and the tips of the fingers. To practice hand drawing, make studies of the hand on its own and think of it like a miniature figure striking little hand-poses, looking for the landmarks in the same way as you might with the whole figure.

Sculptor's Approach

When drawing the hands, think like a sculptor carving them from wood—first, you'll need to rough out the overall shape, then chip away at details like the fingers.

When you're establishing the hand, think about the flow of the arm into it, the gesture flowing through the arm itself, and consider the intention of the pose: is it a languid arm? A dancer's sweeping gesture? Is it grasping for something? Sketch down its limits, the position of the wrist, the farthest tip of the fingers, and line them up with other parts of your figure to get the hand in proportion.

At the construction stage you'll want to find several elements: the wrist, the block of the back or palm of the hand, the knuckle line, the mitten of the fingers, and the shape of the thumb. Divide the mitten into fingers, thinking about the negative spaces between thumbs and fingers. As before, refine the finger shapes as you elaborate on the forms.

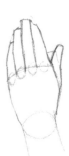

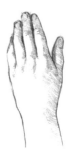

Establish

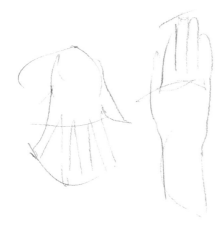

Construct: Mitten

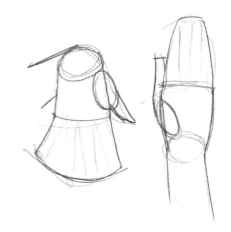

Construct: Divide

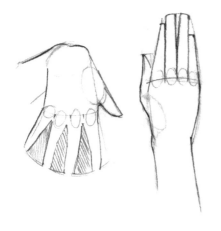

Elaborate: Line

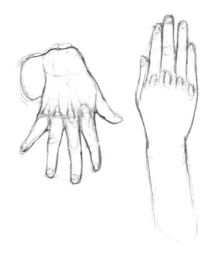

Feet

The feet provides a stable base for the pose, usually
working together to support the weight of the figure.
Feet are bigger than you imagine—about the length
of the forearm. Similar to the hands, you can take a
sculptural approach to drawing them, sketching big
shapes first and chipping away at the detail. Although
the foot is a complicated shape, it can be simplified
into three major planes that in turn can be simplified into
more basic shapes: a triangle on the inside foot, running
from ankle to heel to big toe; a sloping triangular plane on
top of the foot, with a wedge for the toes; and a triangular
underside, which makes footprints in sand.

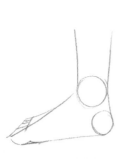 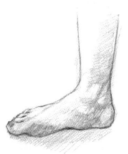

Inside plane

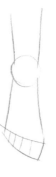

Top plane

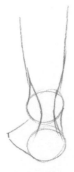 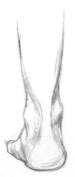

From behind

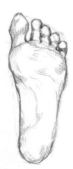

Underside

When you're trying to make sense of the foot just think about which planes you are seeing. The heel and the ankle are important landmarks, and the line of the Achilles tendon can help you connect them both. The lower leg is critical to how we see the foot—the back of the legs bulge, with the calf muscles tapering to the ankle, and tendons operating the toes from farther up the leg. The shin is seen as a hard edge of bone running down from the knee, contrasting with the muscular flows elsewhere in the leg.

Establish

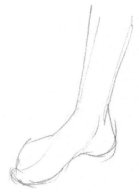

Construct: Landmarks

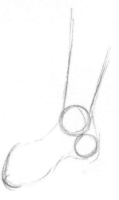

Construct: Planes

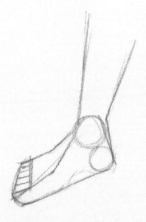

Elaborate: Line

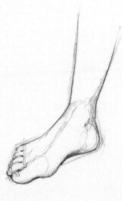

The Head

When you're drawing the figure, think of the head as an object. It's easy to get caught up in the details of the face, but this is a small part of the mass of the whole head: the neck, the hair, and the shape of the skull all contribute to our overall impression. During short poses you'll have a very small amount of time to sketch the shape. Don't just leave the head out; treat it as simply as possible, looking for key shapes that give it direction and gesture, almost as though the head were another limb. Look at the shape of the neck, the back of the skull, hair, and the face with the nose leading the direction of the pose.

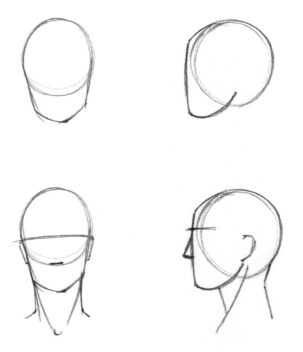

Landmarks of the head.

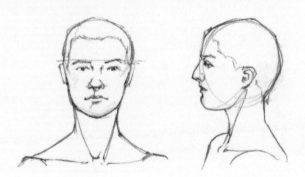

Look at the relationship between the head, shoulders, and neck.

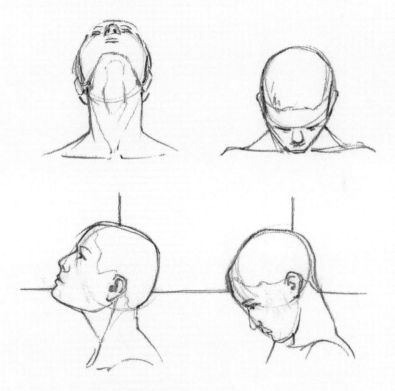

As the head tilts, the features of the face compact and the top of the head or neck become more prominent. The ear is a pivoting point.

The Face

Don't be intimidated by the face; just like any other part of the visual world it can be simplified into shapes and lines. As human beings, we have developed an astounding sensitivity to the nuanced expressions, proportions, and individual differences of the face. Look for the dark shapes in the features, and draw what you see, not how you expect the features to look. It helps to have an order to work through when drawing the face: try starting from the eyebrow line, spiraling down and around the edge of the face. Try combining this approach to the head as a whole to find an approach that works for you.

Hair

When drawing the hair look firstly at the overall shape, tone, then hair texture.

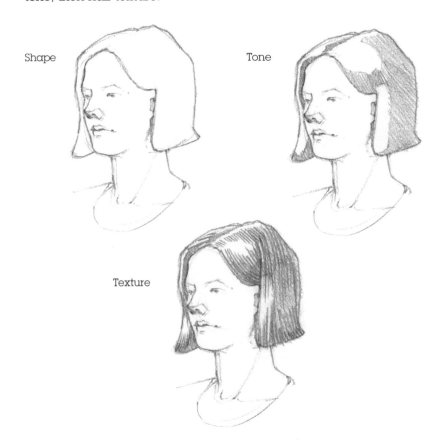

Shape

Tone

Texture

Establish

Construct: Landmarks

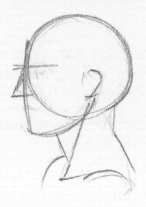

Construct: Features

Elaborate: Shadow shapes

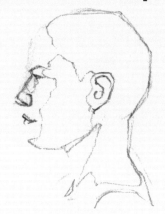

Elaborate: Line

Elaborate: Tone

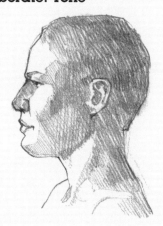

Using Anatomy

It's possible to draw the figure without knowing anything about how the anatomy works. To make a good observational drawing you just need to look, and draw what you see. However, a certain amount of knowledge about how the body works will make it easier for you to see the important features of the figure, and to make decisions about exactly how to capture the essence of a pose.

A working knowledge of human anatomy will both improve your figure drawing and your understanding of your own body. Knowing whether a protrusion you see on the surface you are drawing is caused by bone or muscle beneath it might inform the kind of marks that you use to draw it.

What You Need to Know

The skeleton is the scaffolding on which the body is constructed, bringing rigidity to the figure. Muscles anchor to the skeleton via tendons and facilitate movement by contracting. They're paired to allow for opposite movement, so an extensor muscle might facilitate a finger to extend and a flexor muscle will facilitate the opposite movement.

You don't have to know the names of muscles or bones in order to recognize and draw them, although learning the names of important bones and muscles makes it easier. As you work through the body, you will find that there are structures that are of greater or lesser importance. Learn major, visible structures first, then hone in on parts of the body that interest you and learn about them in greater detail.

Researching Anatomy

Start a notebook for yourself, recording observations about the body and noting elements of the figure to research. Then go away and look those body parts up in an anatomy book, ideally one written for artists. Don't just copy the anatomical diagrams, but look for expressions of anatomy in living people and relate that to your research. Think about the movements that muscles and bones facilitate.

If you want to test your knowledge, try drawing parts of the body from memory. If you have trouble working out what goes on in a particular area, learn more about the anatomy of that part of the body.

An Example: the Neck

Here is an example of how you might use an understanding of anatomy to better inform your life drawing. Beginners often over-simplify the shape of the neck, misrepresenting its relationship with the shoulders. A little research into the structure of this area will help to make sense of what you might see and make more informed drawings. The skeleton and the intermediate muscles are the most important elements to recognize as they create significant shapes on the surface of the skin. Learn about the visible elements of the neck first, then develop your knowledge further if you wish. Think about what each muscle does and what movement it facilities. I have kept to colloquial annotations as a more accessible starting point.

Using Anatomy

The clavicle (collarbone) is a curved bone, although the shadow it creates on the surface of skin can often appear relatively straight. It runs from the acromion process in the shoulder to the manubrium at the top of the chest. The shape of the spine gives structure to the neck, particularly when seen in profile, and the ribcage provides an anchoring mass on which the shoulder girdle sits. The skull sits at the top of the spine, with the shape of the mandible (jawbone) playing a large part in the visible shape of the neck.

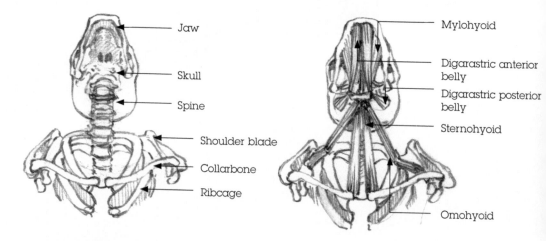

Jaw

Skull

Spine

Shoulder blade

Collarbone

Ribcage

Mylohyoid

Digarastric anterior belly

Digarastric posterior belly

Sternohyoid

Omohyoid

Musculature

The first diagram shows the deeper muscles and the less-visible, significant intermediate muscles of the neck, included for completeness. It's the second and third diagrams you'll want to concentrate on, showing the following muscles: the sternocleidomastoid muscles are two tapering columns that join the clavicle to the mastoid process behind the ear. When they both contract, they bring the head to the chest, and can contract independently to help turn the head. The trapezius, a cape of muscle, extends from the back of the skull, down the back of the neck to the middle of the back giving a triangular mass to the shoulder from the front. The platysma softens the front of the neck, facilitates

grimacing expressions, and can flick the skin of the neck. Also look out for the cartilage of the Adam's apple (the thyroid cartilage, present in both men and women), and the windpipe (trachea).

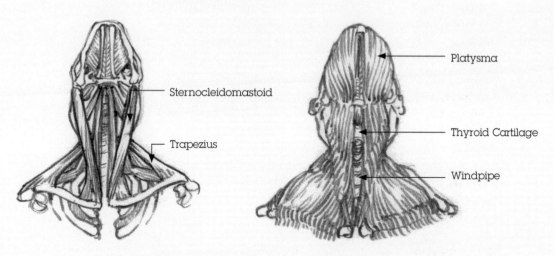

Sternocleidomastoid

Trapezius

Platysma

Thyroid Cartilage

Windpipe

Drawing the Neck

In a drawing of the neck, the jawbone provides the gateway from the head into the neck. Lines of the sternocleidomastoid give the impression of the neck tapering to plug into the chest, and the trapezius creates a coat-hanger shape on the shoulders with the collarbone giving structure to the front of the chest.

Construction

Elaboration

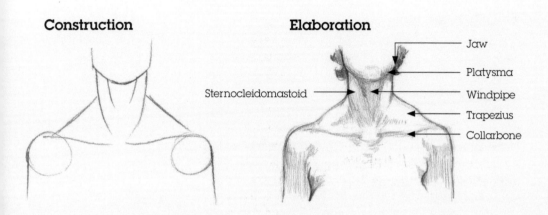

Sternocleidomastoid

Jaw

Platysma

Windpipe

Trapezius

Collarbone

Foreshortening

Foreshortening is a word used to describe the optical distortion created by the effect of perspective on an object: chiefly, that a length along the line of sight will appear relatively shorter than a comparable length across the line of sight. It's not a special kind of perspective in itself; it's a term normally used to refer to an isolated object or figure rather than an entire composition. Some degree of foreshortening is always present in observational drawings—it's just not always a significant issue. In a life drawing class, you'll always be seeing the model within a fixed space, and once you have become familiar with the problems you might expect, it will make it easier to make sense of your observations.

Cylinder from the side Foreshortened cylinder

Foreshortening in a cylinder: viewed from the end, it has more compact proportions than when viewed from the side. The farthest end is drawn smaller than the nearest end.

When you're looking at a foreshortened pose, parts of the body that are farther away will look smaller than those that are nearer. The distances between landmarks will appear compacted, and your brain will want to interpret the subject in such a way that you may find yourself playing down the effects of foreshortening in your drawing. At the construction stage, use measuring techniques to check major distances, as well as checking the vertical and horizontal relationship between landmarks in the body. Draw what you see, not what you expect to see.

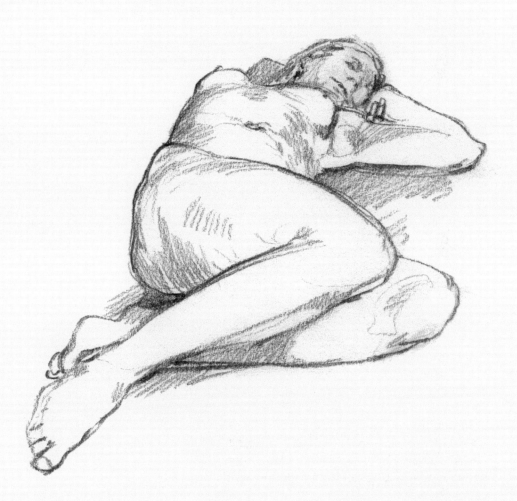

Body Shapes

We all have different body shapes; our bodies change over time and are affected by our genetics, age, gender, diet, and lifestyle. Superficial details such as scars, hair, and tattoos will also affect how we go about drawing somebody. Life drawing provides an amazing opportunity to see the body in its most essential state and can help you appreciate the breadth of human variety. Really great life drawings often tap into something essential about the model, the result of the artists bringing an empathetic eye to the drawing, and capturing something that is true. Don't get too caught up with your expectations of a figure; base everything on your observations of the individual who is in front of you.

Sex

We can make broad generalizations about the differences in how men and women put on fat or muscle, and societal gender norms will affect how some men and women grow their hair or use and manage their bodies. However, it is important to remember that there can be more variation between one man and another of differing body shapes as there might be between a man and a woman with similar figures. Men and women have very similar structural anatomy—the major difference in anatomy is between male and female genitalia, and drawing the genitals well in a life drawing session is really just about observation. You can't properly draw what you haven't observed. Breasts are a significant superficial shape in the female torso and vary significantly in shape and size, becoming lower and flatter with age. Women have the same chest muscles as men, which are often partially obscured by the shape of the breast. Men still have mammary glands, however; they are simply smaller and functionless. On men and women the nipples are a very useful mark point in navigating the proportions of the chest.

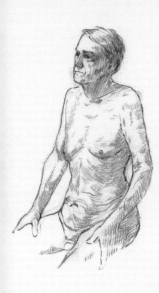

Age

A body that has been lived in longer tells stories about that person. On younger bodies, the skin is smoother and tighter; on older bodies, the effects of gravity and changing body mass makes it hang, stretching it. This might give more insight into the musculature below the skin as well as creating superficial wrinkle lines to draw.

Fat and Muscle

Many different variables affect how a person's body looks, and the proportions of bone, muscle, fat, and skin play the largest role in visual differences. More developed muscles create a more defined body structure, while build-ups of fat soften the lines of the figure. We all share common musculature developed to different degrees by our different lifestyles. We also all have some portion of fat in all of our bodies. On slimmer figures, indicators of skeletal structure might be seen as protrusions under the skin—for example, the iliac crest often creates a sharp edge of shadow on a slim figure. On a model with more body fat, the skin either side of the iliac crest bulges, forming a dimple where the skin is attached to the bone. On a more muscular figure, the external oblique can be developed to a point that the underlying bone structure is obscured. Look for and think about these kinds of variations in different figures.

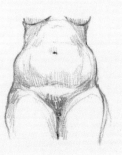
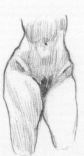
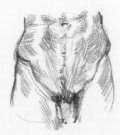

RUNNING A LIFE DRAWING SESSION

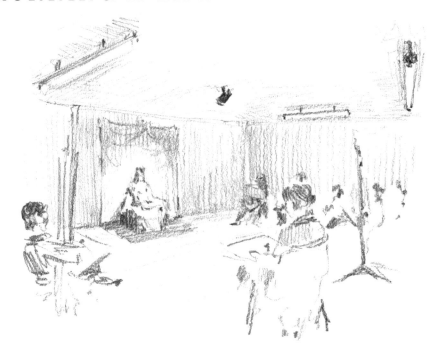

Life drawing classes aren't always readily accessible. Most life drawing classes exist outside of structured educational institutions and are set up by models, artists, or groups of friends; some are publically advertised, others are kept small and private. If you have trouble finding a local class that suits your needs, you might want to set up your own session, or try drawing a friend. This chapter offers advice on how to set up a space and run a small life drawing class, and the last part of the chapter (see page 124) contains additional advice on running a one-to-one model sitting.

Questions to Answer

In order to a set up and run a small life drawing class, you need to have thought about the following aspects of the session; go through these questions and make sure you can answer each one. The rest of the chapter contains guidance on answering the questions.

STUDIO

- Is the space private?
- Is there a changing area for the model?
- How will the model and artists be arranged in the room?

HEATING
- Will the space be warm enough for a life model?
- Will you need additional heaters?

LIGHTING
- How is the space lit?
- Do you have good lighting for the model?
- Will the artists have enough light to draw by?
- Will you need to bring additional lighting?

EQUIPMENT AND FURNITURE
- What will you need for the session?
- What will already be in the studio?
- What will you bring to the studio?
- What will you ask people to bring?

DRAWING MATERIALS
- Will you be recommending or prescribing materials for the class?
- What will you provide?
- What will you ask people to bring?

SESSION LEADER AND ARTISTS
- Who is session leader for the class?
- Will all responsibilities for the class be with one person, or be shared?
- What information will artists attending the session need beforehand?

MODEL
- Who will model?
- How will you find a model?
- What is your plan if the model doesn't arrive?

POSE TIMINGS
- How long is the session overall?
- How will the session be structured?
- What will the pose timings be?
- How will the class be introduced?

The Studio

You'll need a space to draw in and it will need warmth, light, and privacy. You might hold the session in an artist's studio, a community hall, a function room, your own house, or any space that provides a suitable environment. Wherever you hold it, we'll call it the studio, and you'll need to have considered the following:

IS THE SPACE PRIVATE?
Privacy is important for your model's comfort, but also to allow the artists to relax into their drawings. Make sure nobody is going to need to come into the space during the session; put a "life drawing in progress" sign up on any doors and cover any overlooked windows.

IS THERE A CHANGING AREA FOR THE MODEL?
It is important that your model has a private space in which to get changed, and somewhere safe to leave their clothes. A bathroom can work just fine, as long as the model doesn't face a long walk in their dressing gown. Otherwise, a folding screen or fabric hung on a line can work for dividing off a small space.

HOW WILL THE MODEL AND ARTISTS BE ARRANGED IN THE ROOM?
Decide the modeling area in advance and mark it out in some way. Think about the lighting when arranging the space, and available plug sockets of heaters. Circles and semi-circles often work best for maximizing the amount of people you can get around the model. Set up chairs or easels in advance to guide where people place themselves. Over the page you'll find example set-ups.

Heating

Make sure that the room will be warm enough for an unclothed model, bearing in mind the ambient heat and time of the year. Think about bringing in extra heaters if necessary. Ceramic heaters provide good directional heat; convection heaters take time to heat a room up; fan heaters are directional but can be loud and are not always ideal. All models have different comfortable temperatures; get to know the preferences of regular models.

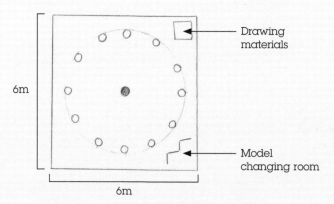

6m

6m

Drawing materials

Model changing room

Setup in the round—large space with easels

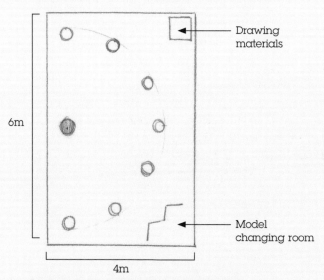

6m

4m

Drawing materials

Model changing room

Semi-circle set up—small space with chairs

Lighting and Equipment

In the absence of a lamp or spotlight, position the model below and to one side of overhead lights for good sculptural shadows. Some ceiling-mounted spots that can be directed at the model ideal, otherwise domestic lamps on a tall stand can provide adequate directional light. For strong sculptural shadows, use dark fabric drapes to block ambient light around the model and use a single light source above, in front and to one side of the model, angled at about 45 degrees.

Make sure the model is aware of where to stand to create the ideal shadows on their figure; when you are modeling it is hard to know how light looks on you, and you rely on the session leader for direction. Research photographic lighting techniques for lighting advice, and experiment before the class.

A professional lighting setup

An improvised lighting setup

Lighting for the Artists

Think about how the artists' paper will be lit. Ambient, overhead lighting is ideal. In a professional studio, strip lighting is often placed behind and above the artists with a guard on side to stop light from strips interfering with the directional lighting on the model. If you need extra lighting for the artists, then up-lighting bounced off walls and ceilings is preferable to spot lighting.

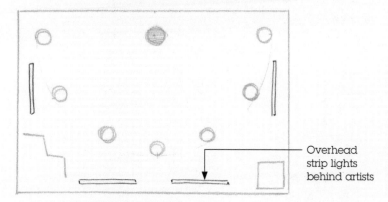

Overhead strip lights behind artists

A professional setup.

Equipment and Furniture

As a minimum you'll need chairs or stools for the session. You might also need small tables, easels, and drawing boards. Make sure you know what is available in the space, what you'll be bringing, and what you'll ask people to bring.

Drawing Materials

If you are tutoring the session, you might want to prescribe the materials that the artists will use; let them know what they need to bring and what you will provide. Decide whether you will provide all of the materials for the session, no materials (in which case, make sure that people know to bring their own), or ask people to bring their own but keep a few basic materials on hand for anybody who has forgotten their kit.

Running the Session

Having clear roles in a session is important. The model should be obvious enough, but it is important to ensure that the session leader takes responsibility for the safety and comfort of both model and artists. A well-managed space where everybody understands the ground rules of the session is essential for the smooth running of the class. Before people attend the class, make sure they know what to bring, the lengths of poses they should expect, and whether it will be a life class, a costumed session with full figure pose, or a portrait pose. Naturally you'll also want to specify time, location, and cost.

The Life Model

You can often find a life model though other art groups, art schools, and adult education institutions. If possible, it is worth meeting the model before the class to ensure they know what will be required of them. It is also worth checking with other classes and tutors to find out what the standard pay would be for a session in your area. If you can't find a model to pose unclothed for your session, try a costumed drawing session, or invite the artists to take it in turns to each model for a clothed pose. Make a plan in case the model doesn't turn up, and bear in mind the following points. They're not rules, but are useful guidelines.

- Empathize with your model; bear in mind how you would feel in the situation, unclothed in front of the class.
- Some models are happy finding their own poses, some might want directions, or you may wish to request a particular pose. You can't direct a disinterested life model into good poses, but you can spoil a good life model's poses by over-directing them; discuss the poses beforehand and allow the model to find something that is aesthetically appropriate and sensible to adopt.
- A good model will want to do the best poses possible for a class. Talk them through the needs of the group before starting, and explain what kind of session it is (is it made up of short, energetic poses; will the group benefit for clear views the model's face; etc.).

- Ensure the model is never blamed for breaking a pose; help less experienced models find poses they can hold for the given timespan, and if it is clear they are in unreasonable pain, take it upon yourself to stop the pose.
- Once you have asked the model to adopt a pose of a particular length don't ask them to extend the pose part way through. If the model has adopted a 5-minute pose, it is likely the most energetic they can hold for that time.
- Ask the model how they are doing as they pose; give them opportunities to stretch, and check the temperature is okay.
- Model yourself at least once; see what it is like to hold different lengths of poses.

Pose Timings

Before you begin drawing introduce the session, explain the lengths of poses and introduce the model. This gets the session off on the right foot and helps establish your role as session leader. You can structure a session however you like; typically a few short poses of a few minutes each can be used as a warm-up, or included at the end of the session to practice the skills developed in the longer drawing. Try either, or both. A break every hour gives both models and artists a chance to rest, talk about their drawings, and have refreshments.

TYPICAL 2-HOUR "MIXED POSE" CLASS
10 minutes – Setup and introduction
15 minutes – 5 x 3-minute poses
30 minutes – 2 x 15-minute poses
15 minutes – Break
45 minutes – Long pose
05 minutes – Clear up

TYPICAL 3-HOUR "LONG POSE" CLASS
10 minutes – Setup and introduction
45 minutes – Long pose part 1
15 minutes – Break
45 minutes – Long pose part 2
15 minutes – Break
45 minutes – Long pose part 3
5 minutes – Clear up

Running a Private Sitting

If you cant get to a life drawing class, or you want to get some figure drawing done between sessions, you might want to ask a friend to sit for a drawing. Here are some guidelines on how to run a sitting with a model. It could be an unclothed pose, but will most likely be costumed.

So You Need a Model

One of the advantages of a life drawing class is that the model is likely to have been drawn before and will have few expectations about how you will draw them; also as part of a class there is less pressure to make "good" drawing. If you are drawing a model one-to-one they will often have more expectations of what you produce. If your first drawings are drawn in a one-to-one sitting you want to find a model who wont mind a few unflattering sketches being made of them!

If you need someone to draw at home, learn to draw with a friend. Take it in turn to pose for drawings; you can help one another progress and share tips and revelations. By posing for a drawing yourself you'll also learn to empathize with your own models. If you can't find somebody to draw with, try exchanging sittings with friends or family for a meal, gardening, etc. A fair exchange of time can take away some of their expectation that you should create a "good picture" early on.

How to Run a Model Sitting

A session drawing from a model is called a "sitting" and the model a "sitter." Even when it is a very friendly and informal sitting there are a few things that are worth bearing in mind, particularly when drawing people who are not used to being drawn.

- Firstly, be straight with your model about the level of experience: it will help you to throw yourself into the drawing without apprehension.
- Set yourself an overall time limit for the session; an hour in total is realistic, giving time for a chat, quick poses, a stretch, and a longer pose.
- Sit the model down comfortably and chat to them for a few minutes without drawing; explain what you'll be doing in the drawing and explain that you need them to remain still, but that they can relax and find a position that is comfortable.
- Once you're ready to start, give your model somewhere to look; this will help them keep still. Put on some music to help you both relax.
- Make some quick drawings of 5-minute poses to find a pose and composition you're happy with. These will get your eye and hand working together and will help you to learn the shape of your model's figure, clothes, and features.
- After several studies, have a break and let the model stretch if they're feeling stiff from staying still. Then try for a longer 15-minutes picture; be strict with your timekeeping and know when to stop.
- Be honest with yourself about what the sitting is for: If it's a chance to sketch and chat, keep it light and expect to make less considered drawings. If you are trying in earnest to learn and make better drawings, you might want to cultivate a more serious atmosphere. It is easy to get caught up in playing the artist. If you find yourself worrying about whether you look like a "proper artist" as you draw, then you're not paying enough attention to the model and your drawings will suffer for it. In the words of my own teacher, John T. Freeman, "It should only be the model who is posing."

References

Exploring Drawing

Life drawing classes can be one of the best ways to meet other keen draftsmen. There's nothing better than finding a group of people who share the joyful revelations of looking and sketching and who have experienced and overcome the same obstacles as you in learning to draw.

Many adult education centers offer structured courses in portrait or life drawing and most towns will have small art societies. Drop-in life drawing classes and drawing clubs can be a sociable way to draw and to meet others who draw, and an internet search will often yield a wealth of groups in your area. If no local groups exist, find friends who might like to learn to draw with you and use some of the advice in the last chapter of this book to help set up your own drawing sessions.

Many galleries and museums have public art programs. The Campaign for Drawing lists drawing events in the UK and internationally as part of their Big Draw initiative. I run classes at various institutions in London and through my own drawing school, Draw Brighton.

If you'd like to share your drawings on social media you can tag them with the hashtags #drawpeople #drawfaces #lifedrawing.

Essential Further Reading

Drawing Projects
by Mick Maslen and Jack Southern

Anatomy for the Artist
by Sarah Simblet

Other Useful Drawing Books

The Natural Way to Draw
by Kimon Nicolaides

Keys to Drawing
by Bert Dodgson

The Drawing Book
by Sarah Simblet

Portrait Drawing
by John T. Freeman

DRAW
by Jake Spicer

Draw Faces in Fifteen Minutes
by Jake Spicer

Draw People in Fifteen Minutes
by Jake Spicer

Online Resources
Draw Brighton
www.draw-brighton.co.uk

Jake Spicer
www.jakespicerart.co.uk

The Big Draw
www.thebigdraw.org

Twitter and Instagram

@BrightonDrawing

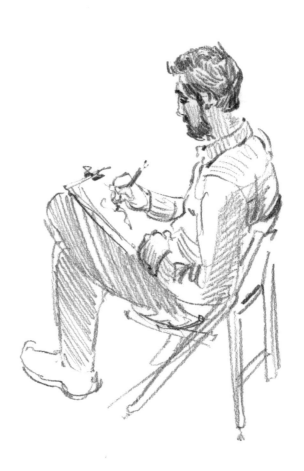

Acknowledgments

This book is dedicated to Francesca Cluney, queen of life models.

I'd like to thank Hester Berry, Shelley Morrow, Laura Burgess, Mary Martin, and Rob Pretorius for their enduring support at Draw Brighton. I'd also like to thank Duncan Cromarty for constant feedback, Tim Patrick for stimulating discussion, John T. Freeman and Jane Alison for their support and input, Sarah Simblet for her generous advice, and Tammy Cherriman and my family for indulging my life long love of drawing.

I'd especially like to thank the life models models and artists drawn in this book: Laura Burgess, Amy Squirrel, Colette Tarbuck, Bella Franks, Michaela Meadows, Felix Clement, Mary Martin, Ken Reed, Isabel, Emma Sandham King, John Pinney, Harriet Duke, Beth Hodd, Arry Tappiheroe, Laura Nenonen, Keith Mercer, Chris Perry, Laura Kate O'Rourke, Lana McDonagh, and any of the drawing class who managed to make it into a drawing!

Finally, thanks to Rachel, Roly, and Zara, and all the team at Ilex Press for their patience and support.

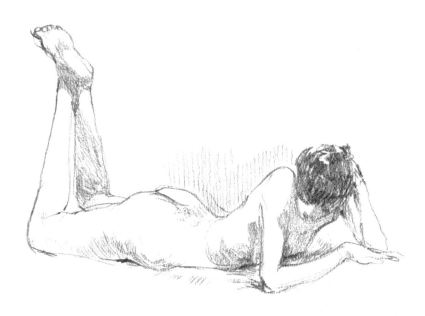